ROSALYND C. PIO

D0184777

# Masterpieces of the

# BARGELLO

## Guide to the Museum

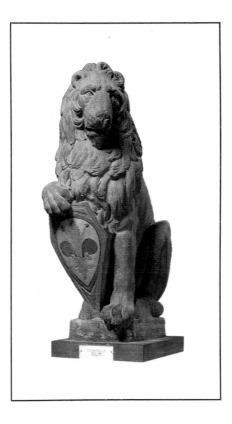

BONECHI EDIZIONI ·IL TURISMO· - FIRENZE

# CONTENTS

Cover: **The Pitti Tondo**, by *Michelangelo.*

Frontispiece: **Marzocco**, by *Donatello.*

Back-cover: **The Bargello courtyard** (19th century print).

© Copyright 1992 by Bonechi – Edizioni "Il Turismo" s.r.l.
Via dei Rustici, 5 – 50122 Firenze
Tel. (055) 2398224 – Fax (055) 216366
All rights reserved
Even partial reproduction forbidden
Printed in Italy

**ISBN 88-7204-001-9**

*Photographs:* Bonechi Archives; Marco Rabatti and Serge Domingie
*Computer Maps:* Carlo Fusi
*Lay-out, Graphics and Cover:* Piero Bonechi and Barbara Bonechi
*English version:* Rosalynd C. Pio
*Editorial Coordination:* Simonetta Giorgi
*Typesetting:* Leadercomp, Florence
*Reproduction:* RAF, Florence
*Printing:* Lito Terrazzi, Florence

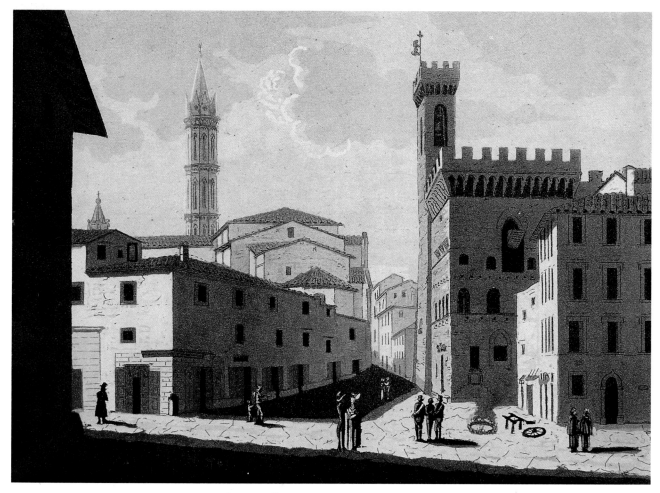

The Bargello Prison in a 19th century print.

# HISTORICAL NOTE

There is a plaque on the façade of the Palace of the People (today's Palace of the Bargello) that praises Florence, destined, like Rome, to great glory and secure justice, foretelling its rôle as capital of Tuscany. The plaque commemorates the advent of the First People (Primo Popolo) in 1250. The Constitution of the Primo Popolo, led by a Captain, assisted by 12 Elders (two for each Sixth of the town), was the first democratic form of government in the West. After using the Monastery of Santa Croce, the Baptistery, etc., the need for a suitable place, in which the Council of the People would be able to foregather, became mandatory and houses and towers belonging to the Boscoli, as well as land belonging to the parishes of Sant'Apollinare and Santo Stefano alla Badia, were purchased (1255) and, according to Vasari, Lapo, a follower of Arnolfo and according to others, Fra Sisto and Fra Ristoro, were given the task of building the new palace. Enlargements, restorations, made necessary by fire, revolts, pillaging mobs and the river Arno overflowing its banks, delayed the completion of the palace, to the extent that it was only in 1367, that Benci di Cione and Neri di Fioravante finally

concluded the building operations, which did not prevent Guido Novello (King Manfredi's Deputy) from living in the palace as from 1261 or that the Podestà be reinstated in the palace in 1266. In 1326, it was the official residence of the Duke of Calabria, summoned to rule over Florence by its citizens, after the defeat of Altopascio. Later on, in 1502, after the title of *Podestà* had been abolished, the palace became the headquarters of the *Council of Justice* and of the *"Ruota"* (the roster of magistrates succeeding each other by rota) and in 1574, of the *Captain of Justice*, or *Bargello*. The Bargello was an official, generally not a Florentine, appointed by the Signoria or Council of the Lords, whose executive functions were aimed at maintaining the public peace. The word seems to come from *Barigildus* or *Bargildio*, probably a Longobard word, already mentioned in the Carolingian Chapters (e.g. in Lothair, in 825). In the same year, the loggia in the courtyard was walled in and the terrace or *Verone*, as well as the other rooms, were tranformed into as many prison-cells as possible. The Edict of the 5th July 1782, issued by the Grand Duke Peter Leopold, abolished the

3

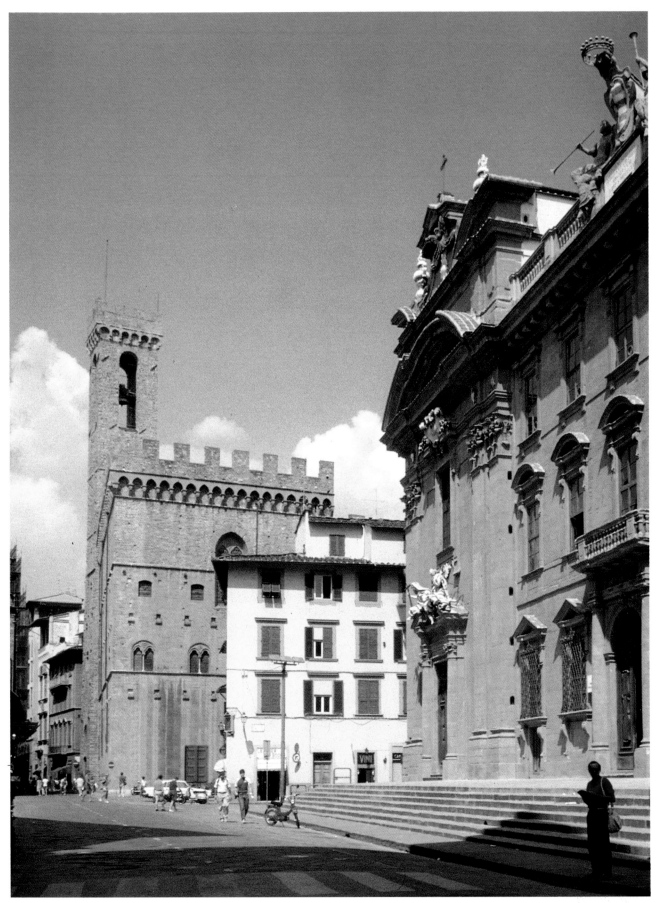

Piazza San Firenze with the Church of San Firenze on the right and, beyond, the Palace of the Bargello.

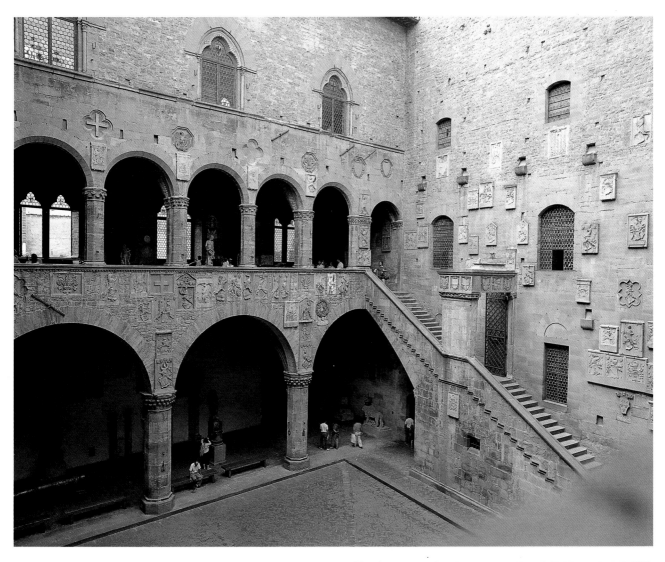

Above: **the south-western corner of the courtyard, seen from above;** right: **the crests of the Judges of the Ruota and of the Podestà against the western wall of the courtyard.**

*Tribunal of the Holy Office* (Inquisition) all over the territory of Tuscany and all the instruments of torture (wheels, racks, iron shoes, hand-cuffs, shackles, thumb-screws, funnels and whistles), were burnt in the courtyard of the palace. The only one of these horrible instruments to survive — an iron collar, spiked on the inside — is to be seen in the Armoury Room. In 1786, the Grand Duke also abolished the death penalty. Later on, from 1856 to 1865, the architect Francesco Mazzei, with the aid of the erudite historian Count Luigi Passerini and the painter Gaetano Bianchi, restored the palace to its ancient splendour. The National Museum of the Bargello was officially inaugurated in 1865. The most ancient part of the building is the front side (overlooking Via del Proconsolo); it is slightly higher than the rest of the palace and dates back to 1255; the rear, overlooking Via della Vigna Vecchia and Via

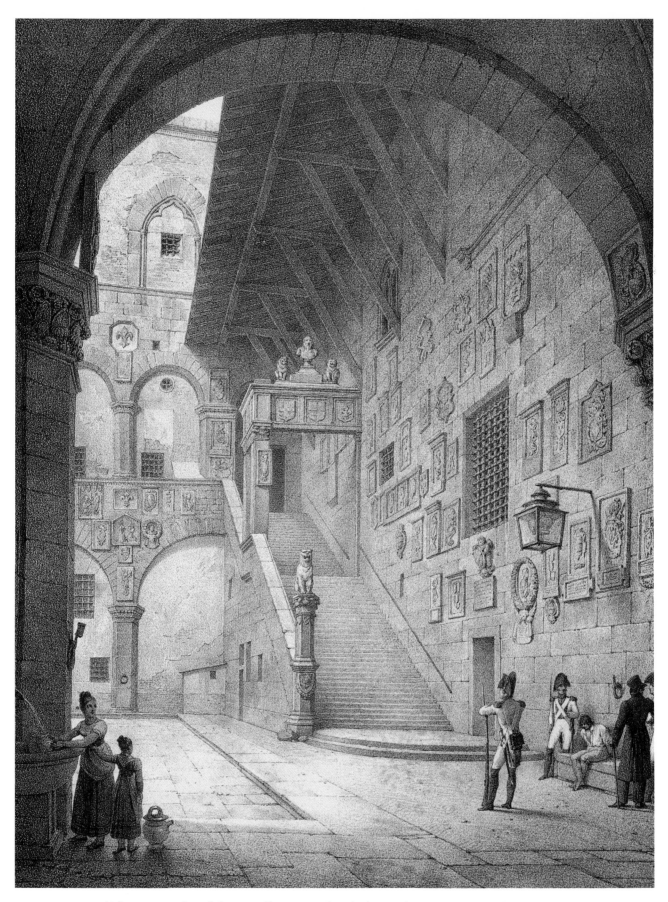

19th century print of the Bargello courtyard with the overhanging eaves and the portico and the loggia transformed into prison cells; opposite: the courtyard as it appears today.

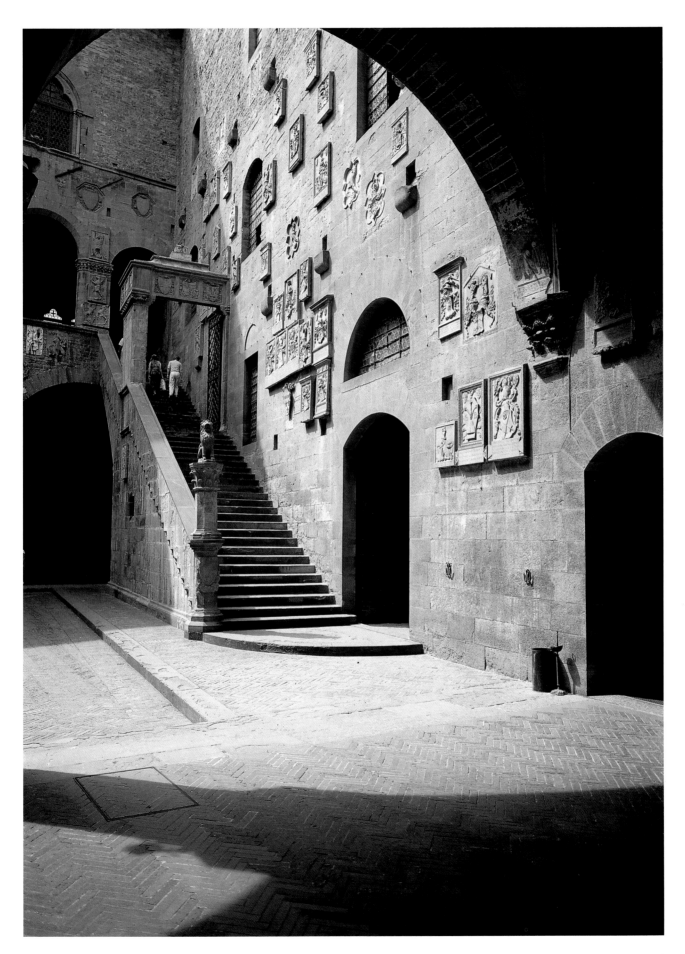

dell'Acqua, was constructed between 1325 and 1346. The 57 meter-high battlemented tower, which existed before the palace, was named Volognana, as from 1267, when the banished Ghibelline knights, under the command of Master Filippo da Cuona or da Volognano, besieged in the fortified convent of Sant'Ellero, surrendered to the Guelphs. Young Geri da Volognano was taken to Florence and immured in the cell in the tower of the Palace of the People, to die of hunger. Since when the tower has born the name of the unfortunate young man's family. The bell-chamber contains the famous bell, known as the *Montanina*, which was captured from the Castle of Montale, in 1302; after it cracked, it was recast in 1381, with the following inscription: *To the honour of God and for the freedom of the Country*. To start with, it summoned the people to gatherings, later, it tolled for the hearings of the judges or for public executions and in the evenings, it announced the hour after which it was forbidden to walk armed through the streets. Nowadays, it only rings on special occasions and on the last day of every century. Iron cages used to be hung from the windows of the tower, containing the prisoners condemned to the pillory. The Signoria would cause people accused of treason, who had managed to escape from punishment to be portrayed hanging by their feet, on the walls of the tower. Thus Giottino, in 1343, portrayed the Duke of Athens; Andrea del Castagno, the opposers of Cosimo the Elder; Sandro Botticelli, the members of the Pazzi Plot, etc. Public executions often took place at the door of the palace on Via Ghibellina and the heads of the beheaded would be exhibited for three days, for the "satisfaction" of the people. The fairly common punishment of hanging people by their hands tied behind their backs, after which they were given one or more sudden tugs (tratta di corda), which dislocated their shoulders, was inflicted both inside and outside the palace. The little door, on the eastern side, on Via dell'Acqua, led down to the dank dungeons beneath the palace. At the corner of Via Ghibellina, a shrine contains a fresco (now detached, for restoration), showing *St. Bonaventura visiting the prisoners*, by Fabrizio Boschi (1588).

**GROUND FLOOR**

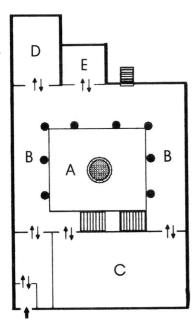

**FIRST FLOOR**

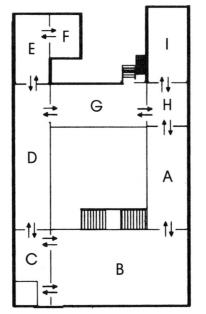

**SECOND FLOOR**

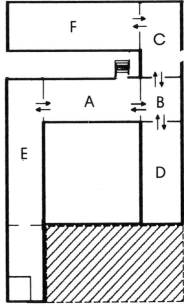

A - Courtyard
B - Portico around the Courtyard
C - The Michelangelo and 16th century Sculpture Room
D - Medieval Sculpture Room
E - Temporary Exhibitions Room

A - Terrace (Verone)
B - Donatello or Audience Hall
C - Islamic Room
D - Carrand Legacy Room
E - Chapel of the Podestà
F - Sacristy
G - Ivories Room
H - Bruzzichelli Legacy Room
I - Maiolica Room

A - Giovanni della Robbia Room
B - Andrea della Robbia Room
C - The Verrocchio and late 15th century Sculpture Room
D - Bronze Statuettes Room
E - Armoury
F - Medals Rooms

# TABLE OF DATES

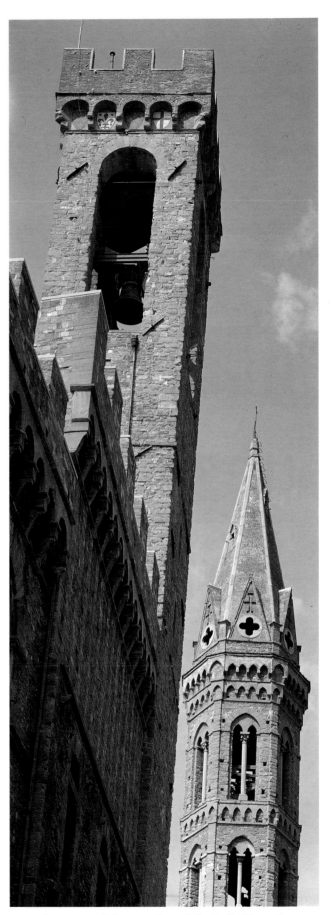

**The towers of the Bargello and the Badia Fiorentina.**

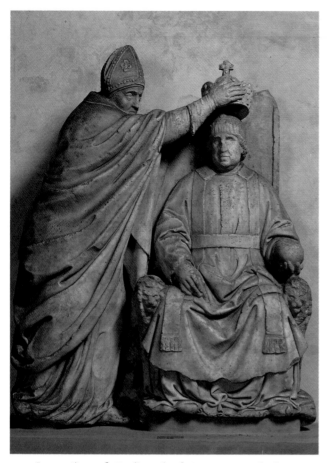

Coronation of Ferdinand of Aragon or of Char-lemagne, Florence, 15th century; below: **Cosimo de' Medici as a Roman emperor,** by *Vincenzo Danti*.

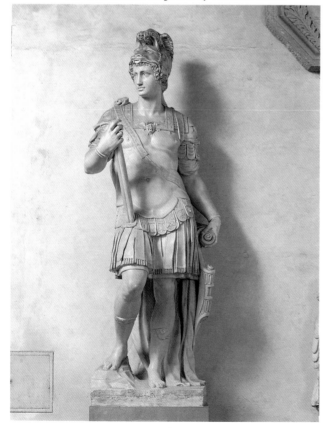

**NOTE**

THE OBJECTS AND WORKS OF ART IN EACH ROOM OR SPACE IN THE MUSEUM ARE LISTED FROM LEFT TO RIGHT AND FROM TOP TO BOTTOM, STARTING FROM THE ENTRANCE INDICATED, UNLESS OTHER-WISE STATED.

# THE COURTYARD

(A – Ground Floor). In the Entrance Hall, where one purchases ones tickets, one can admire a case of **Medals** with portraits in profile and *Beatrice*, a bronze statue of a female nude, by Francesco Messina (Cata-nia, 1900-living); on the walls: spears, halberds, armo-rial crests and reliefs. One emerges into the picturesque courtyard, surrounded on three sides by a lofty portico, with octagonal pillars. The walls are covered with the badges and crests of the *Podestà* and *Auditors or Magistrates of the "Ruota"*, who succeeded each other for three centuries in the palace. See also the emblems of the *Quarters*, *Sixths* and *Gonfalons* (the standards of the Military Companies for the defence of the town), reconstructed during the last century. The monumental stairway, built by Neri di Fioravante (1345-67), climbs up to the first floor, against the western wall. At the foot of the steps, a stone *Marzocco* (or lion) crowns the newel post. Halfway up: a portal with a beaten *iron gate*, designed by Giuliano da Sangallo, once surmount-ed by two lions and by the statue of St. Catherine of Alexandria, the virgin martyred in 312: the patron saint of the Tribunal of the "Ruota" (i.e.: wheel — roster or rota of judges). Above the southern side of the portico, the *Verone* (or Terrace), attributed to Tone di Giovanni (1319), an architectural jewel, with a double number of arches compared with the underlying portico, its semi-circular arches supported by octagonal ribs, that recall the arches of the Loggia of the Priors, in Piazza della Signoria, built about half a century later. Proceeding clockwise, one notices:

**Roman Sarcophagus**, surmounted by **two** 15th cent. **dolphins**.

**Cosimo I de' Medici**, by Vincenzo Danti (1536-1586). A remarkable example of Mannerist sculpture and an idealized portrait of the Medici duke, as a Roman emperor. Once situated in the Hall of the Five Hundred, in Palazzo della Signoria.

**Coronation of Ferdinand I of Aragon, or Char-lemagne** (?), by unkown 15th cent. Florentine sculptor. An interesting high relief (flanked by six statues of musicians, of different provenance), which has occa-sioned much debate, as both the identity of the sculptor (Benedetto da Maiano?) as well as the name of the sovereign are uncertain.

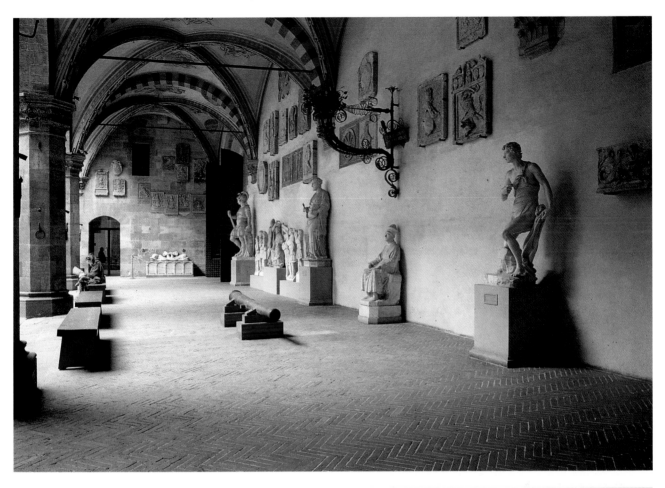

The northern portico; right: **Oceanus**, by *Giambologna*.

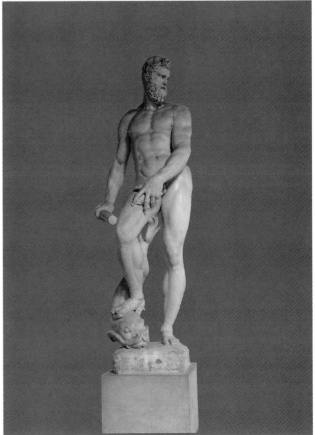

**St. Luke the Evangelist** (1404), by Niccolò di Pietro Lamberti (Florence 1370-c. 1451). Once in the shrine of the Judges and Notaries at Orsanmichele, the statue was replaced by another in bronze, by Giambologna. As one of the artists working on the construction of Santa Maria del Fiore, Lamberti absorbed many of the stimuli which also influenced Donatello. Later on, in Venice, together with his son, Pietro and Paolo Uccello, etc., he directed the restoration of the Basilica of St. Mark's, after the 1418 fire, helping to spread the ideas of the Renaissance throughout the Venetian lagoon area.

**Bronze Cannon or Falcon**, cast by Cosimo Cenni, for Cosimo III de' Medici, in 1620. It bears the Medici crest and the Cross of St. Stephen on the barrel; on the breech: the planet Jupiter with its four satellites (just discovered by Galileo Galilei and named by him *Medici Stars*).

**Beaten Iron Lamp**, by Giulio Serafini, from l'Aquila, 16th cent. In the form of a horn of plenty; from the Gualtiero Palace in Orvieto.

**St. John the Baptist**, attributed to an unknown 16th cent. Florentine artist and by others to Gian Lorenzo Bernini (Naples 1598 - Rome 1680).

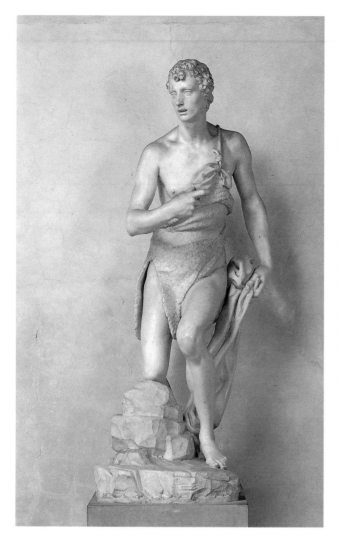

**Architrave**, by Benedetto di Bartolommeo de' Grassini, known as da Rovezzano (1474-1552). From the Badia Fiorentina doorway.

**Holy Water Stoup**, in marble, 14th cent. Florentine, with the badge of the Bordoni family and the date 1302.

**Juno and two Peacocks, the River Arno; Allegory of the Earth; the River Arbia; Temperance, Allegory of Florence**, by Bartolommeo Ammannati (1511-1592). The statues were meant to decorate a great fountain (to be placed opposite the Audience Dais in the Hall of the Five Hundred, in Palazzo della Signoria), which was never finished; they were later used by the Grand Duke Francesco I to adorn the Medici Villa of Pratolino (1559). Ammannati's finest works are his Michelangelo-like nudes of Sansovino-like grace, that nonetheless reveal the artist's indipendent, assured and vigorous vision, capable of delightful and refined detail. As an architect, he was no great innovator, but deserves a place beside some of the most renowned masters of the Mannerist period.

**Fiesole**, by Niccolò Pericoli, known as Tribolo (1500-1550). Allegorical stone statue, from the Medici Villa of Castello.

**Clio**, the Muse of History, marble statue by Domenico Foggini (1520-1590).

Left: **St. John the Baptist**, by *G.L. Bernini* or 16th century Florentine (?); below: **Cannon of St. Paul**, cast by *Cosimo Cenni*.

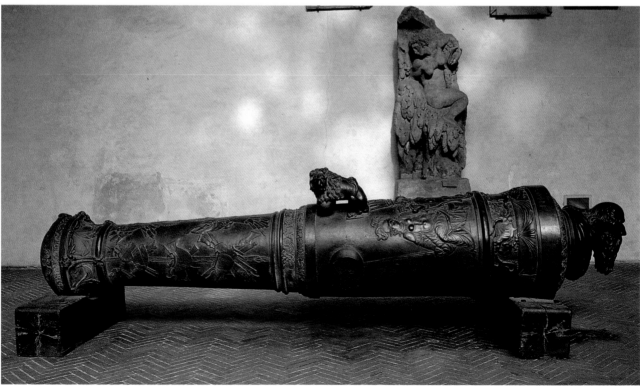

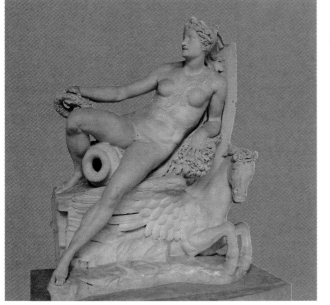

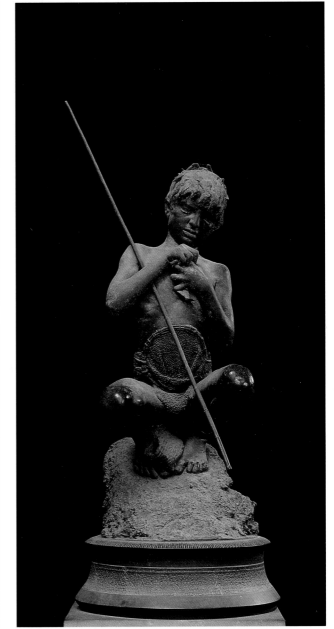

Above: **the Arno**; below: **the Arbia**, both by *Bartolommeo Ammannati*; right: **the Fisher Boy**, by *Vincenzo Gemito*.

**Oceanus**, by Jean de Boulogne, known as Giambologna (Douai 1524 - Florence 1608). It used to crown the great Fountain of the Isolotto in the Boboli Gardens, surrounded by the allegorical figures of the rivers Euphrates, Ganges and Nile (old age, maturity and youth). It is over 3 metres high. The god stands upon a sea-orc, holding the staff of command in his right hand.

**Cannon of St. Paul**, cast in bronze by Cosimo Cenni in 1638, for Ferdinando II de'Medici; intended for the Fortress of Leghorn, it owes its name to the *Head of the Saint*, on the breech. On the barrel: the *Medici Crest*, flanked by the figures of *Justice* and *Strength*, two seated *Lions* (Marzocchi) and, near the mouth, an elegantly decorated *Medusa Head*.

**The Magdalen**, by unknown 17th cent. sculptor.

**The Fisher-boy**, a 19th cent. bronze statue, by Vincenzo Gemito (1852-1929). Exhibited in Paris, in 1878, it confirmed the Neapolitan artist's success, naturally inclined as he was towards a plastic realism, that led to a certain amount of friction with the formal academism of his time.

**Two Lions**, carved by 15th cent. Tuscan master, with iron crowns, from Piazza della Signoria.

**Alphonse of Aragon**, marble statue, from the Aragonese Sepulchre in Naples, attributed to the Circle of Laurana, or to the Workshop of the Sagrera (1450?); it was purchased by the Italian State in 1980.

Crossing the courtyard diagonally one enters the Medieval Sculpture Room.

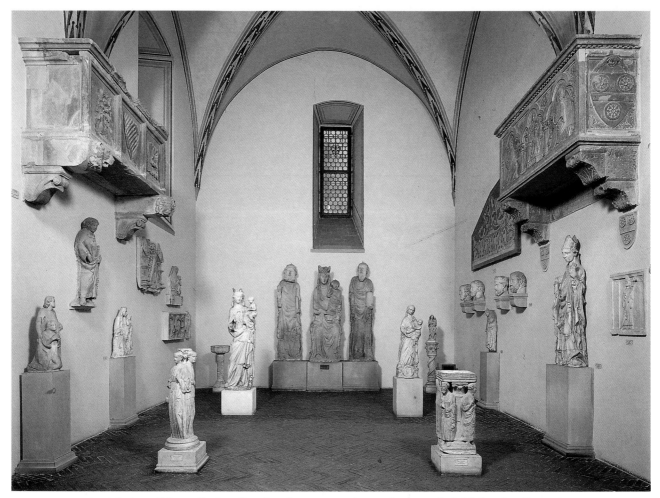

Partial view of the Hall of Medieval Sculpture; opposite: **Madonna and Child,** by *Tino di Camaino*.

# MEDIEVAL SCULPTURE ROOM

(D – Ground Floor). It was opened in 1870 and original- ly contained materials from the demolished monuments and religious buildings that had been suppressed; fur- ther statues, reliefs and architectural elements from religious edifices or monuments all over the Florentine area have been added to the original nucleus.

**14th cent. Sandstone Aedicula,** above the entrance, from Santa Maria Novella. On the side-pinnacles: the *Announcing Angel* and the *Annunciate Virgin.* In the centre of the tympanum: the *Redeemer* blessing, flanked by family crests.

**Frescoed Lunette,** with cross and two lions (?), dated 1229.

**Twin-tailed Mermaid,** marble relief, with floral deco- rations, Romanesque.

**Four Prophets,** stone statuettes, from the windows of Orsanmichele, three of which are attributed to Simone di Francesco Talenti (2nd half of the 14th century).

**Poverty,** marble relief, by Giovanni di Balduccio (active between 1317 and 1349), from Orsanmichele.

**Sepulchre of Lapo de'Bardi di Vernio,** (d. 1342), the head of that powerful and extremely wealthy Florentine family, who, together with the Peruzzi family lent some 1,365,000 golden florins to Henry IV of England and was only remunerated for his "loan", by being granted the right to use the three royal lions on his family crest. The sepulchre, with the original Bardi charge (halberds) comes from the church of Santa Maria Soprarno, which was demolished to make space for the Lungarno Torri- giani, in the 19th century.

**Angel with Donor,** wall statue, by Tino di Camaino (1285-1337). Born in Siena, the artist became Master of the Works at the Cathedral of Pisa in 1315 and later, in Siena, in 1320. In 1323/4, he was in Florence, after which he served the Angevin royal family in Naples, where he met Giotto and Pietro Lorenzetti. His solid figures often remind one of the latter's style.

**St. Pancras,** 14th century Florentine School.

**Madonna and Child,** marble wall statue, by Tino di Camaino. The Virgin, with a book in her right hand and the words "SEDES SAPIENTIAE" carved into the base; almost certainly from the sepulchre of the Bishop Orso, in the Cathedral of Florence.

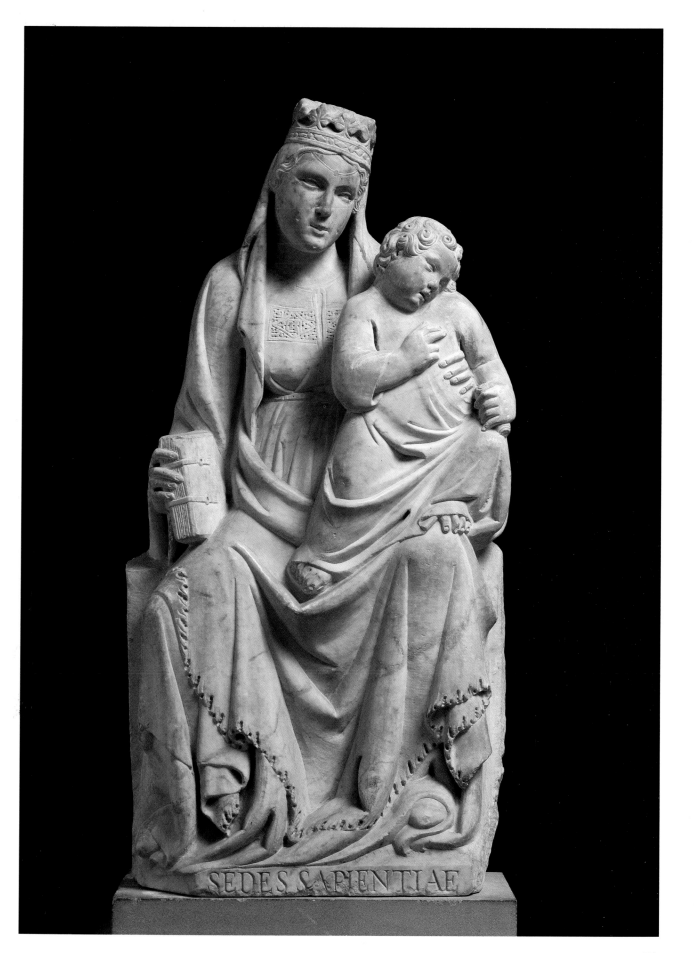

SEDES SAPIENTIAE

**Madonna and Child**, life-size free-standing statue, 14th cent. French School. The Virgin with a flower in her left hand, the Child playing with a little bird. The wide, almost Oriental cast of the face, the slanting eyes and the gracefully curving body are all typically French Gothic features. Purchased by the Museum of the Bargello in 1984.

**Christ Deposed** or **Man of Sorrows**, in tympanum with side-pinnacles, Tuscan, 14th century.

**Madonna and Child**, relief upon bracket, with inscription and family crests (c. 1361), by Alberto d'Arnoldo, or Arnoldi (active c. mid-14th century)

**Madonna and Child between St. John the Baptist and St. Reparata**, stone relief in rectangular frame.

**Announcing Angel**, marble relief, from window or door jamb, Venetian, 14th century.

**Three Acolytes**, three marble figures, grouped to form a column or pedestal, by Arnolfo di Cambio (Colle Val d'Elsa c. 1245-c.1302). The piece, from the Tomb of St. Dominic in Bologna, came to the Museum in 1892. Arnolfo, an architect and sculptor, trained under Nicola Pisano. He first worked on the *Tomb*, designed by his master, for the Cathedral of San Domenico in Bologna, then on the *Pulpit* in the Cathedral of Siena (1265-8), before going to Rome in 1277, where he portrayed Charles of Anjou. He carved the *Sepulchre of the Cardinal de Braye* (1282) in San Domenico in Orvieto. He also carved a *Tomb* and a *Bust of Pope Boniface VIII*, a pair of *Ciboriums* for two Roman churches and the famous *Statue of St. Peter* in the Vatican. His last works were meant to decorate the façade of his lovely Santa Maria del Fiore in Florence. The classical majesty and the Romanesque plastic power of his figures possess an almost Graeco-Roman flavour.

**Holy Water Stoup**, with an octagonal marble bowl, the sides decorated with quatrefoils and acanthus leaves, the marble pedestal of different workmanship, in relief, with vine-tendrils, animals and mythological figures.

**Madonna and Child between St. Peter and St. Paul**, a group of three large stone statues, by Paolo di Giovanni, from the outer arch of the gateway of Porta Romana (c. 1328).

**Madonna and Child between St. Peter and St. Paul,** by *Paolo di Giovanni*.

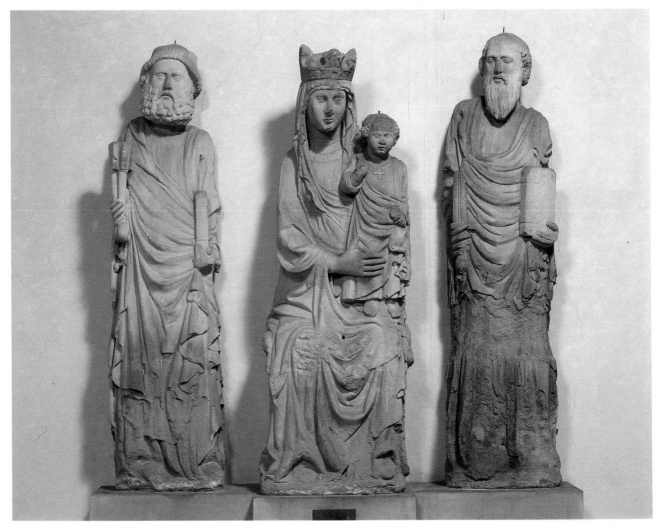

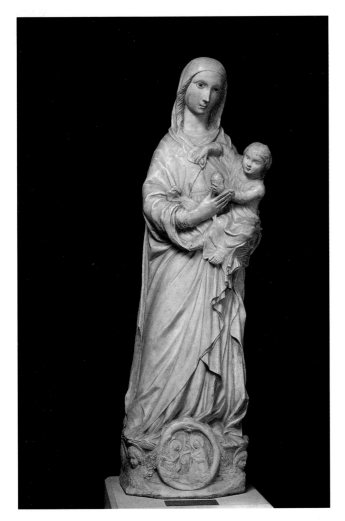

Madonna and Child, *workshop of Domenico Gagini*; right: Three Acolytes, by *Arnolfo di Cambio*.

Madonna and Child, statuette with an octagonal base, upon twining column, Venetian, 14th century.

Mosaic Floor, fragment, Florentine, 9th-11th centuries, once in the church of Santa Trinita.

Four Bearded Male Heads, marble, Tuscan, 14th century.

Allegorical Caryatid, in grey marble, by Tino di Camaino, 14th century.

Madonna and Child, statue in white marble, from the Workshop of Domenico Gagini, 15th century. Small circular relief at the base with *Annunciation* and frieze with angels' heads and family crests. Donated by Marquis Eduardo Albitas di San Patriniano.

Sepulchre of Cione Pollini, stone, 14th century, the frontal relief with *Madonna and Child enthroned*, flanked by two angels bearing censers; beneath the brackets: two family crests; from the monastery of San Martino della Scala.

Bishop Blessing, marble wall statue, early 14th century; once in Santa Maria Novella.

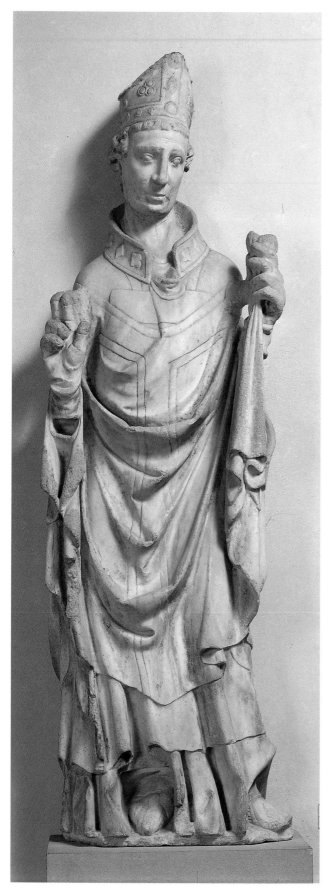

**Bishop blessing,** early 14th century.

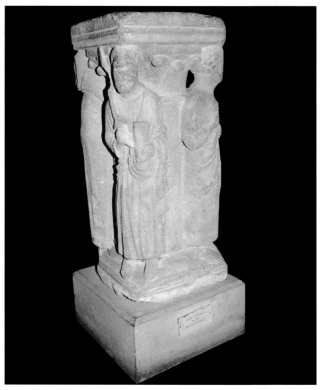

**Holy Water-stoup Stand,** 13th century Pisan School.

**Pedestal for Holy Water Stoup**, with four figures (*two monks* and *Saints Peter and Paul*) grouped around a column with an acanthus leaf capital, Pisan School, 13th century.

**St. Frigidian**, square relief, Tuscan, 13th century.

**Cleanshaven Male Head**, marble, Florentine, 14th century.

**Three Capitals**, each decorated with four human heads and acanthus leaves, on red marble or porphyry columns, Florentine, 13th century.

**Stone arch**, Florentine (1182); in the intrados, in relief: *Vocation of Peter* and *Jesus with St. Benedict* and inscription.

**Bearded Male Head**, marble, Florentine, 14th century.

**St. Michael Archangel**, marble statuette, Florentine, 14th cent.

**Prudence**, marble statuette, Florentine, 14th century.

**Plaque with inlaid ornamentation**, with two concentric circles, Romanesque (1182), donated by E. Costantini (1889).

Returning to the portico, one finds the entrance to the **Temporary Exhibitions Room** to ones left (E — Ground Floor), which is not always open. Inside: two *niches* set into the wall, carved by Benedetto da Rovezzano (1474-1552), from the Da Cepparello palace.

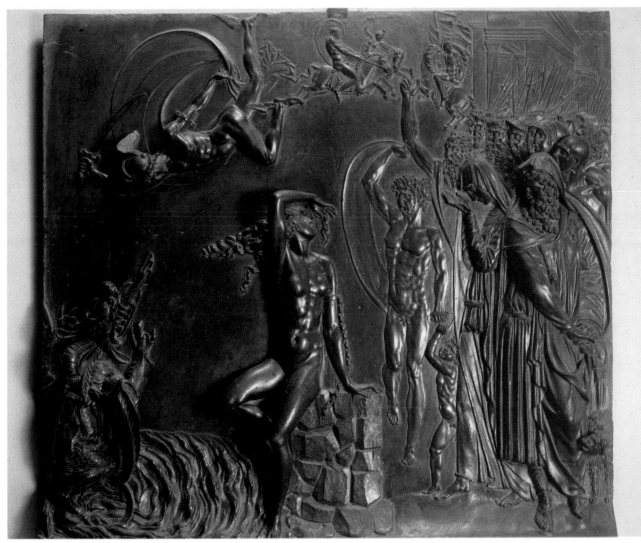

**Perseus freeing Andromeda**, bronze relief, by *Benvenuto Cellini*.

# THE MICHELANGELO AND 16TH CENTURY SCULPTURE HALL

(C – Ground Floor). After the terrible 1966 river Arno flood, the walls of the great chamber (the vaulted roof of which is supported by wide, square pillars) were completely white-washed. On the wall, to the right of the entrance, is the frescoed **Madonna and Child enthroned with worshippers**, attributed to Taddeo Gaddi. Near every door or window, there are paired columns of rare marble or jasper, of varying dimensions.

**Bacchus**, by Michelangelo Buonarroti (Caprese 1475 - Rome 1564). One of the first Roman works of the artist (1496/7), commissioned by the banker, Jacopo Galli, a lover of Greek and Roman antiquities, who kept the statue in his garden for a number of decades, together with various antique statues. Vasari mentions it as follows: "He bears a cup in his right hand and in his left

a tiger-skin and a bunch of grapes, which a little satyr seeks to eat thereof;… it is most manifest that he did desire to compass a certain mingling of marvellous limbs and particularly that he did give him the sprightliness of a beardless youth and the rounded softness of a woman". Bacchus (for the Romans) or Dionysus (for the Greeks), son of Zeus and Semele or Thyone (the wild one) or Persephone, or Demeter, was the god of unbridled fertility, represented by the vine and by wine. The death of vegetation in winter was explained as the flight or death of the god, followed by his return to life, heralded by the rising spring sap. The wild, even fierce rites honouring the death and reappearance of the god were celebrated by women alone, towards the winter solstice: after drinking wine mixed with various hallucinatory drugs, they roamed the woodlands and mountain-sides, devouring the raw flesh of the victims offered to the god. In this guise, they were called *Maenads*, *Bacchae*, or *Thyads* (the wild ones). The god is nearly always represented as a naked, almost woman-like, soft-limbed youth, with flowing locks crowned with a

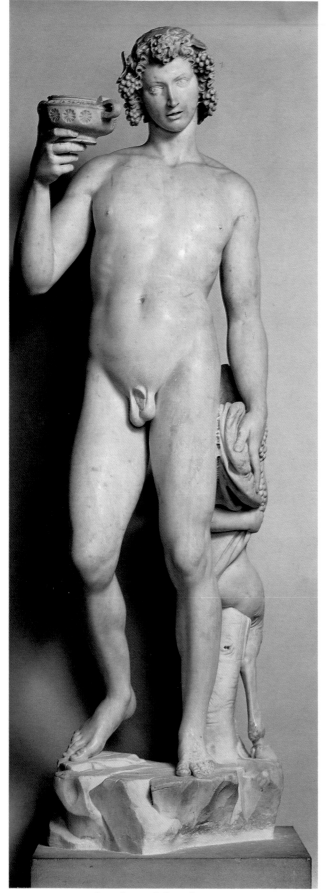

**Bacchus**, by *Michelangelo Buonarroti*.

vine or ivy-wreath, a panther skin and a bunch of grapes in his hand, escorted by fauns, silenuses or maenads.

**The Pitti Tondo**, by Michelangelo Buonarroti. The work was carved during the same years the artist was working on the *David* and on the *Doni Tondo* (1504-8). It comprises the figures of the Madonna, the Child and little St. John, revealing the influence of Leonardo da Vinci's innovative «chiaro-scuro» technique. The head of the Virgin projects beyond the contours of the tondo, reminding one of the dynamic *Sibyls* in the frescoes of the Sixtine Chapel in Rome. It came to the Bargello in 1873.

**Brutus**, by Michelangelo Buonarroti. It was carved for Cardinal Ridolfi, after the assassination of Lorenzino de' Medici, himself the murderer of the hated Duke Alexander de'Medici, towards 1540. It was possibly left unfinished because of the artist having second thoughts as regards the nature of political tyrannicide. Upon the base, a distich, carved by the Medici: "DUM BRUTI EFFIGIEM SCULPTOR DE MARMORE DUXIT IN MENTEM SCELERIS VENIT ET ABSTENIT" which seems to support this hypothesis.

**David-Apollo**, by Michelangelo Buonarroti. Carved after the capitulation of Florence (1530-32). Vasari writes: «(The artist) also began a marble figure for Baccio Valori (the Papal Commissioner) of an Apollo, drawing an arrow from his quiver, to gain favour and make his peace with Pope Clement VII and with the Medici House…» Michelangelo had in fact designed the fortifications for the defence of Florence against the besieging forces of the Spanish Emperor and the Medici. The work was also named David, as the rounded form beneath the youth's foot recalled the head of Goliath. It belonged to Cosimo I's collection, thereafter it was placed in the amphitheatre of the Boboli Gardens and after that, in 1824, in the Uffizi Gallery. In 1871, it was moved to the Bargello. The melancholy of this musing figure evokes the sadness that must have bowed down the rebellious spirit of the artist in those years of crushing defeat.

**Madonna and Child with little St. John**, marble tondo (c. 1505), by Giovan Francesco Rustici (Florence 1474-Tours 1554), commissioned by the Silk Merchants Guild. A pupil of Verrocchio's, Rustici was much influenced by Leonardo da Vinci, a great friend of his, who probably helped him to cast the great, pictorially expressive bronze group, with its early Renaissance modelling of *St. John the Baptist Preaching*, above the northern door of the Baptistery in Florence (1506-11). He was also influenced by Andrea del Sarto and Michelangelo. He gives 15th century motifs an intrinsically pictorial flavour, as in this tondo.

**Bacchus**, marble statue, by Jacopo Tatti, known as Sansovino (1486-1570), commissioned by Giovanni Bartolini. The artist's model was one Pippo del Fabbro, a young apprentice of his. Later, the statue was placed

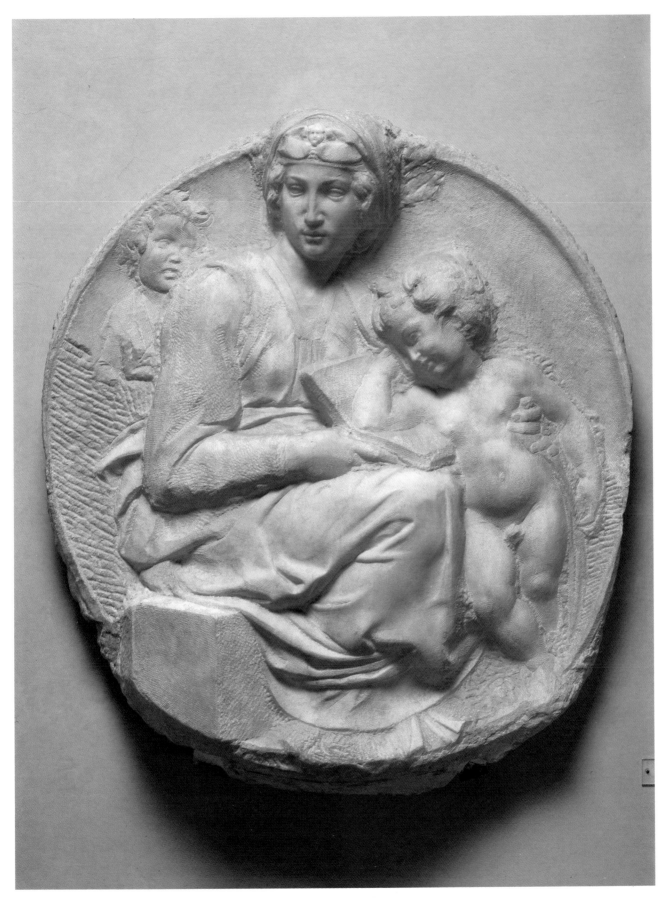

**Madonna and Child with St. John (the Pitti Tondo),** by *Michelangelo Buonarroti.*

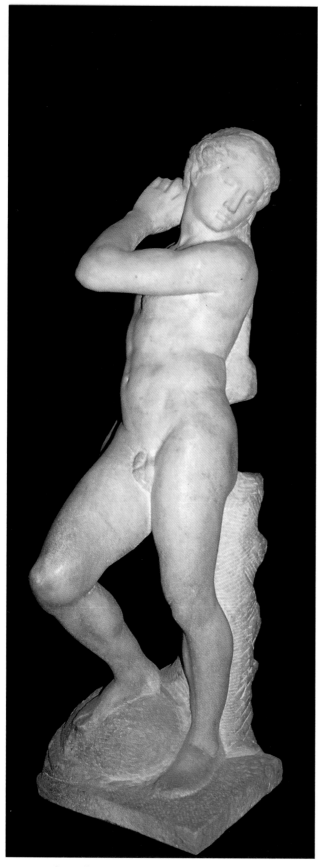

**David-Apollo** and, opposite: **Brutus**, a marble bust, both by *Michelangelo Buonarroti*.

in Cosimo I de'Medici's chambers, in Palazzo Vecchio, then in the Uffizi Gallery, where it was unfortunately much damaged by the 1762 fire. Jacopo Tatti was a pupil of Andrea Sansovino, whose nickname he took for himself. An admirer and later a rival of Michelangelo, he was active in Rome (1518) and later on in Venice (1527), where he worked at length, both as a sculptor and as an architect.

IN THE CASES:

**Moses**, terracotta statuette, by Pietro Francavilla (Cambrai, France 1548-1615), a pupil of Giambologna. The statuette is based on Michelangelo's *Moses* in Rome.

**Dusk and Dawn**, terracotta statuettes, after Michelangelo's statues in San Lorenzo, by Niccolò Pericoli, known as Tribolo (1500-50).

**Day**, terracotta statuette, after Michelangelo's statue in San Lorenzo, by Tribolo.

**The Appennine**, by Jean de Boulogne, known as Giambologna (Douai, France 1524 - Florence 1608), terracotta model for the great statue in the Medici Villa of Pratolino.

**River**, terracotta statuette, by Tribolo.

**Aaron**, terracotta statuette, by Pietro Francavilla.

**Samson and the Philistine**, bronze statuette, 16th century Florentine School, after Michelangelo.

**River**, bronze statuette, after Michelangelo, 16th century, Florentine School.

**River**, bronze statuette, after the *River* by Michelangelo, in the Buonarroti House, 16th century Florentine School.

**Honour vanquishes Deceit**, by Vincenzo Danti (Perugia 1530-76), terracotta model for the great marble statue in this room. The most renowned of a family of artists, Vincenzo was chiefly a sculptor. At the court of Cosimo I, he worked on the decorations for Michelangelo's funeral (1564) and on those for the wedding of Francesco I de'Medici (1565). A post-michelangelesque Florentine Mannerist flavour pervades many of his works.

**Samson and the Philistine**, bronze statuette, after Michelangelo, by Pierino da Vinci (Vinci 1529 - Pisa 1553). Nephew to the great Leonardo, he mastered the sculptor's craft under Baccio Bandinelli, although he was also influenced by Tribolo. Later-on, in Rome, he restored a number of antique works, and perfected his style by studying Michelangelo's sculpture and painting.

**Moses**, marble statuette, after Michelangelo's *Moses* in Rome, 16th century, Florentine School.

**Leda and the Swan**, small marble group, after Michelangelo, by Bartolommeo Ammannati (Settignano 1511-92).

**Bust of Cosimo I** (1544), by Baccio Bandinelli (Florence 1488-1560). Baccio was apprenticed to Rustici. He managed to secure the favour of the Medici and

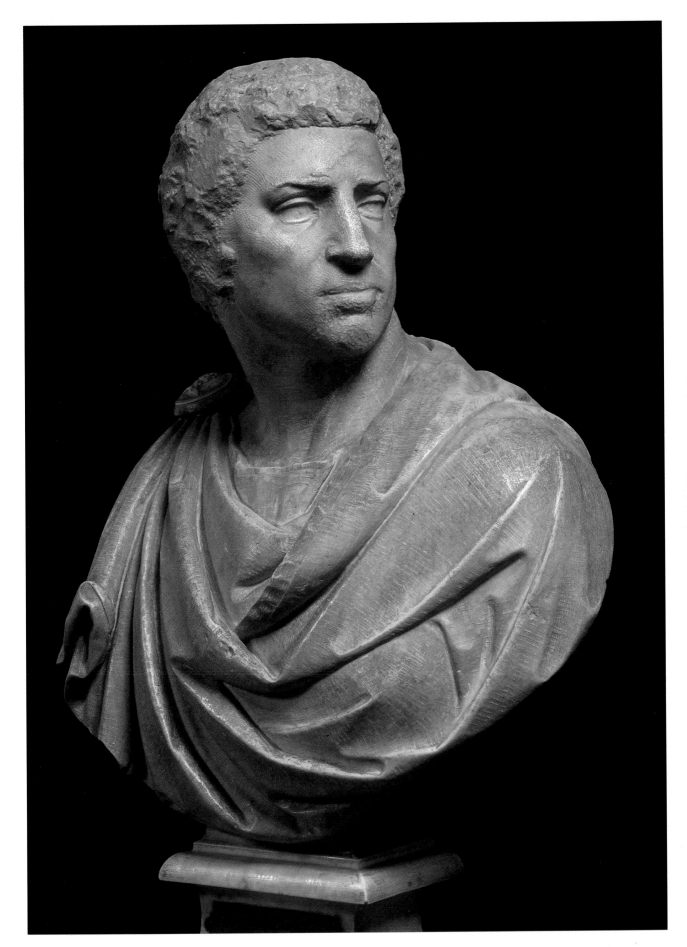

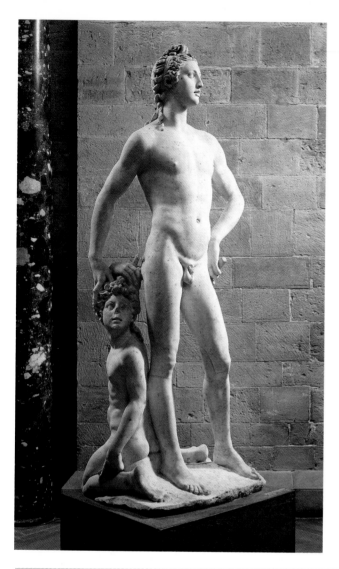

thereafter pitted himself against Michelangelo and Cellini. He was also acquainted with Sansovino. His polished surfaces and his excessively studied modelling recall the Mannerist modes of Rosso, Pontormo and Bronzino. Notwithstanding his unlikeable personality, Vasari recognized his right to be ranked amongst the foremost artists of his time. He was a most fecund sculptor.

**Adam and Eve**, two great marble statues (1511), carved by Baccio Bandinelli for the Cathedral of Florence. The remarkably refined modelling technique is somewhat impaired by a measure of unconvincing complacency. The group was placed behind the great altar of the Cathedral of Florence in 1551, only to be replaced later by Michelangelo's third *Pietà*, as the nudes offended the bigoted prudery of the counter-reformation.

**Christ on His way to Calvary**, terracotta relief, by Vincenzo de' Rossi (1525-87). A pupil of Bandinelli, he came to Cosimo's court in Florence towards 1560. The piece, with its remarkable neo-donatellian overtones, as well as the two other companion pieces, nearby, earned Vincenzo de'Rossi a share in Bandinelli's project for the great altar in the Cathedral in Florence.

**Christ derided**, terracotta relief, by Vincenzo de'Rossi, companion piece to the above.

**Christ before Pilate**, terracotta relief, by Vincenzo de' Rossi, companion piece to the above.

**Female figure kneeling on a hunched-up male figure**, marble group (c. 1540), by Bartolommeo Am-

Left: **Apollo and Hyacinthus,** by *Benvenuto Cellini*; below: **Dying Adonis,** by *Vincenzo de' Rossi*; opposite: **Cosimo de' Medici,** bronze bust by *Benvenuto Cellini*.

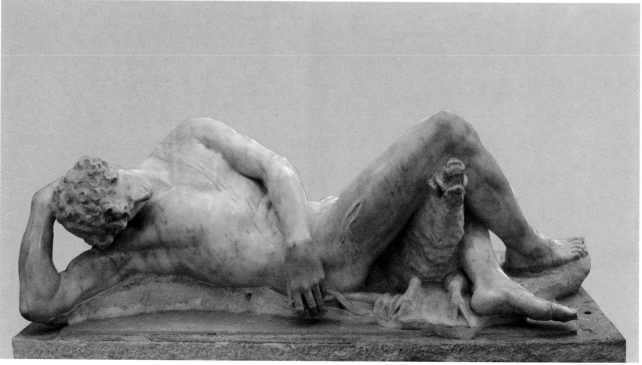

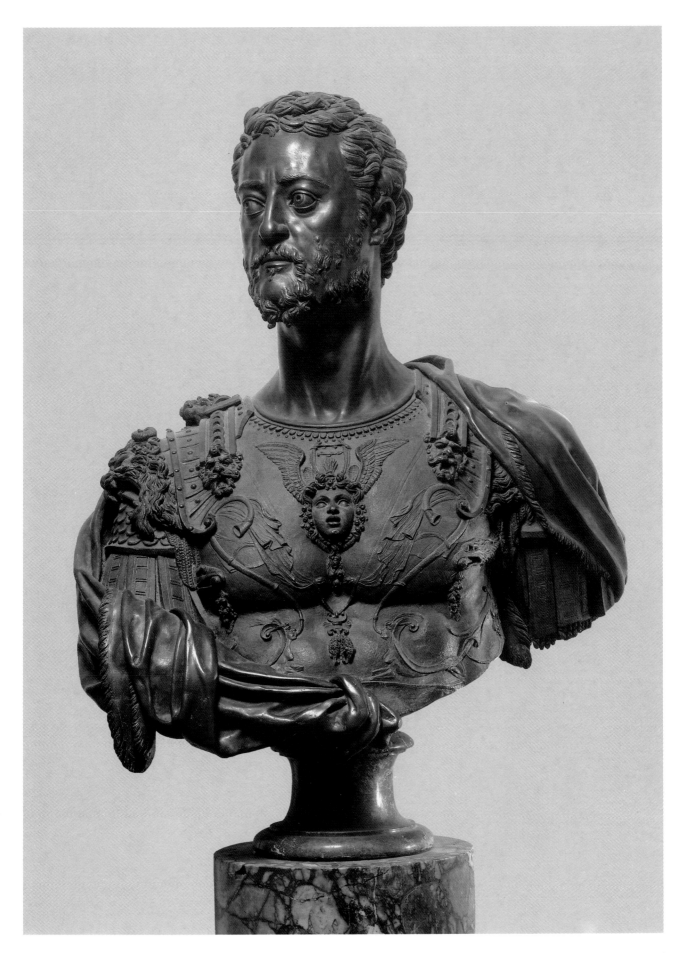

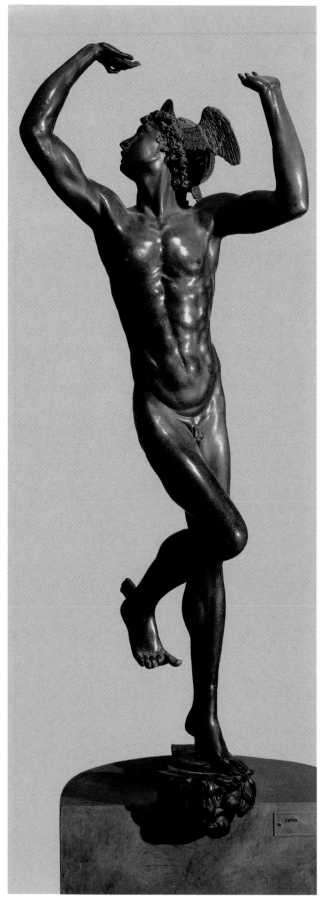

**Mercury,** by *Giambologna*.

mannati, for the *Tomb of Captain Nari*, which was never concluded, because of Bandinelli's hostility.

**Reclining Warrior**, marble statue (1540), by Bartolommeo Ammannati, for the *Tomb of Captain Nari*, in the Church of the Santissima Annunziata, like the above.

**Dying Adonis**, marble statue, by Vincenzo de'Rossi, for a fountain that was never finished. Remarkable michelangelesque overtones in the crossed legs and reclining head of the youth, which led certain critics of the past to attribute this figure to Michelangelo himself.

**Narcissus**, marble statue, by Benvenuto Cellini (1500-1571). Listed as one of the items still in the artist's workshop, after his death (1571), it came to the Bargello in 1940, from the Boboli Gardens. The work was also mentioned by Cellini himself in two letters he addressed to Cosimo I in 1548 (when he announced the arrival of the «Greek marble» to be resculpted) and in 1565 (when the piece was finished).

**Mercury, Danae with Young Perseus, Minerva and Jupiter** (1545-1554), bronze statuettes for the base of the *Perseus*, by Benvenuto Cellini (1500-71), removed to safety from Piazza della Signoria. The masterly grace and technical expertise revealed in these figures remind us of Benvenuto's French sojourn, when he worked as a goldsmith at the Court of Francis I (1540-45). The mythological figures evoke the legend of Perseus, son of Danae and Jupiter, the king of the gods and bearer of thunderbolts, who lay with her, after having changed himself into golden rain. Cellini illustrates Perseus' beheading of the Medusa (the serpent-haired Gorgon, who turned all who looked at her to stone), as well as the freeing of Andromeda (Perseus'future spouse, who was about to be sacrificed to a sea-monster), thanks to the arms supplied to him by Mercury, his half-brother (the "petasus", or winged helm of invisibility, the winged sandals of flight and the sickle-shaped sword) and by Minerva, his half-sister (the mirror-bright shield).

**Perseus freeing Andromeda**, bronze relief, from the *Perseus* group, by Benvenuto Cellini, also removed from the base of the great bronze statue, for reasons of safety and preservation. The visage of Cepheus, king of Ethiopia and father of Andromeda, in the right foreground group of figures, is supposed to be a self-portrait of Cellini.

**Perseus**, bronze statuette, by Benvenuto Cellini, upon a pink marble column. Not mentioned in Cellini's writings, it was probably one of the trial castings for the final great bronze statue of *Perseus* and was, in all likelihood, given to the Grand Duchess Eleonora of Toledo, consort to Cosimo I. The traces of gilding support the hypothesis that it was initially used as the central ornament or finial of a wine-fountain.

**Apollo and Hyacinthus**, marble group (1545-48), by Benvenuto Cellini. Carved from the piece of marble the

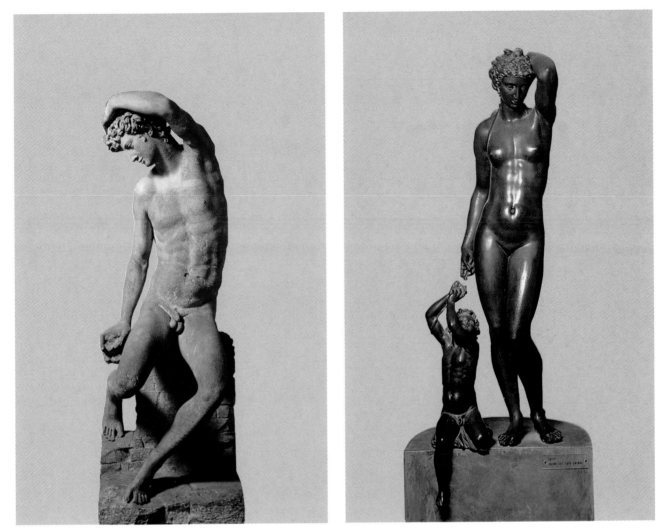

**Narcissus** and **Danae with young Perseus**, both by *Benvenuto Cellini*.

sculptor received from Baccio Bandinelli, it reveals numerous additions and reconstructed parts. In his «Autobiography», Cellini complains of the deteriorated quality of the marble. It was probably transferred to the Boboli Gardens (whence it came to the Bargello) between 1757 and 1779.

**Honour vanquishes Deceit**, marble group, by Vincenzo Danti (1530-76). A follower of Michelangelo, Danti compiled a manual of Mannerist sculptural technique, «Delle Perfette Proporzioni», in which he expressed his admiration for the great master. The group is a demonstration of his theories, recalling Michelangelo's *Genius of Victory*, in Palazzo della Signoria.

**Bronze Door Panel**, by Vincenzo Danti, from Palazzo della Signoria: a reproposal of the *Victor crushing the Vanquished* theme, surrounded by four oval panels with figures. In the lower part: a female figure enthroned, flanked by two slaves.

**Mercury**, bronze statue, by Jean de Boulogne, known as Giambologna (1529-1608). Much admired by Francesco I de' Medici, Giambologna worked on a series of fountains for the grand-ducal gardens. The springing grace of this messenger of the gods and protector of merchants, floating on Aeolus'breath, crowned the fountain of Villa Medici in Rome, in 1598. The statue was brought back to Florence in 1780.

**Ganimede**, marble statue, partly antique, with additions (1548-50), by Benvenuto Cellini. In his autobiography, the artist boasts about his (not very convincing) handiwork on this ancient torso, that was sent to Cosimo I by Stefano Colonna of the Princes of Palestrina. The youth rests his left hand upon the eagle's neck, whilst his right hand holds up an eaglet.

**Florence victorious over Pisa**, great marble statue (1570), by Jean de Boulogne, known as Giambologna. The florid, rounded limbs of sinuous Florence were supposed to be a counter-chant to Michelangelo's *Genius of Victory*, in the Hall of the Five Hundred in Palazzo della Signoria. Florence, i.e.: garlanded Flora crushes bearded, snarling Pisa, crouching over a small sharp-muzzled wolf.

**Cosimo I de' Medici** (1545-7), great bronze bust, by Benvenuto Cellini. Mentioned by the artist in his "Autobiography": "and the first work I cast in bronze was

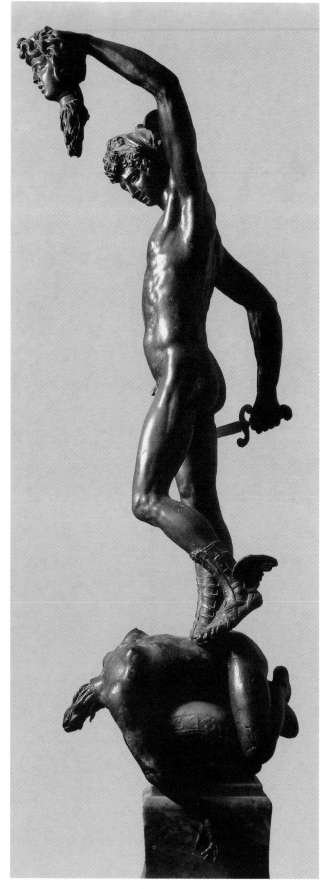

**Perseus**, by *Benvenuto Cellini*.

that great head of His Excellency, that I had modelled in earth in the work-shop... and I cast it for no other reason than for the purpose of experimenting the earths to be used in casting the bronze (the *Perseus*)... I availed myself of the furnace of Master Zanobi di Pagno, bell-master...". Listed as "touched with gold" (the eyes still show traces of enamel and traces of gold are still visible upon the armour), it was placed in 1557 in front of the entrance to the fortress Cosimo I had had built in Portoferraio on the Isle of Elba, where it stayed until 1781, when it returned to Florence, passing from the Uffizi to the Bargello. It was Cosimo, who appointed the first Bargello, as well as putting the philosophical theories described by Machiavelli in his «Prince» into practice. This ruthless, disquieting visage is far more convincingly realistic than the formally bland portrait-bust, carved by Baccio Bandinelli in the same years (also in this room).

**Moses and the Bronze Serpent**, bronze panel in high and low relief, by Vincenzo Danti. The tumultuous composition, highlighted in gold leaf, reveals the technical ability of the artist, who uses both the «schiacciato», i.e.: very low, as well as high relief, to create this throng of vivid, flame-like figures.

**Michelangelo Buonarroti**, bronze bust, by Daniele da Volterra (1509-66). This portrait, like the one at the Academy of Fine Arts in Florence, was commissioned by Leonardo Buonarroti, the nephew of the great Michelangelo. Another similar one is at the Buonarroti House, where only the head seems to have been cast by Volterra, whereas the shoulders and drapery appear to have been cast by Giambologna. It is a vividly realistic portrait of Michelangelo in his fifties.

IN THE CASE:

**Battle**, terracotta group, by Giovan Francesco Rustici. The figures of the warriors and horses are clearly derived from the great *Battle of Anghiari*, which Leonardo da Vinci was commissioned to paint for Palazzo della Signoria and which unfortunately melted away.

**Torso of a Crucifix**, wooden, armless, Florence, 16th century; donated by Ferdinando Gatteschi (1985).

**Little Head**, terracotta, by unknown 16th century sculptor of the Circle of Sansovino.

**Madonna and Child**, small terracotta panel in high relief, by Andrea Contucci, known as Sansovino (Monte San Savino, Arezzo 1467-1529), who was taught sculpture by Antonio del Pollaiuolo. From 1491 to 1501 he lived in Portugal. Back in Florence, he cast the *Baptism of Christ* for the architrave of the *Paradise Doors* of the Baptistery (1502-1505). This Madonna belongs to the same period, revealing the gentle grace and tenderness of his leonardesque classicism.

On the walls of the internal staircase, leading from the courtyard to the upper floors, hang the **Medici Family Portraits** carved in relief in red porphyry on ovals of green serpentine (1560-74), by Francesco Ferrucci del Tadda (Florence 1497-1585).

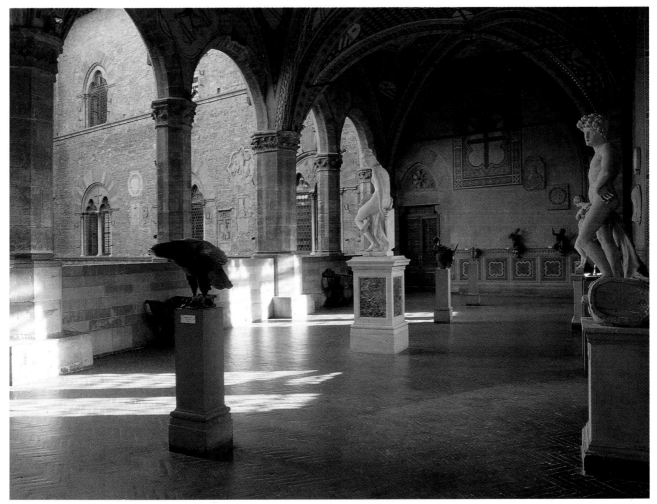

Partial view of the Terrace.

# THE TERRACE (VERONE)

(A – First Floor). The elegant terrace covered by three crossvaults, overlooks the great *Courtyard* through a five-arched loggia. It resumed its original appearance in 1857, during the Mazzei-Bianchi restoration, when the podestàs' escutcheons and armorial bearings on the walls were freed from the plaster, and whitewash that had covered them while the building was used as a jail. A number of statues and plaques in relief have been arranged along the terrace and against its three walls:

**Golden Eagle**, **Barn Owl**, **Turkey**, **Cockerel**, **Falcon**, **Greater Horned Owl**, **Hawk**, **Peacock**, **Hen Pheasant**, bronze statuettes, by Jean de Boulogne, known as Giambologna (Douai 1524 - Florence 1608), from the Grotto of the Animals at the Villa di Castello and commissioned in 1567 by Francesco I. They were brought to the Bargello in 1932 and arranged in this "open-air" space. The naturalistic accuracy of these exceptionally well-cast statuettes is truly admirable. Their original position along the outer side of the loggia exposed them to environmental pollution, wherefore they have now been arranged along the longer wall, but will probably be removed in the near future to the *Bronze Statuettes Room*.

**Architecture**, a marble statue, by Giambologna. This elegant female nude sits on a plynth holding the instruments of her art.

**Fishing Putto**, by Giambologna, from the Casino di San Marco.

**Satyr pouring water**, bronze statue, by Valerio Cioli (Settignano 1529? - Florence 1599); the feet somewhat damaged; from the Medici Villa of Castello. The artist was a pupil of Sansovino and later assistant to Tribolo. He created a host of "genre" statues, used to decorate fountains and gardens, such as, for instance, the Fountain of the Dwarf Barbino, in the Boboli Gardens, commonly known as the *Little Bacchus Fountain*.

**Fishing Putto**, little bronze statue, by Giambologna. This charming piece shows a fish wriggling beneath the child's thigh; from the Casino di San Marco.

**A Pair of Lovers seated on Dolphins**, 16th century Florentine rectangular marble relief.

**Diana and Actaeon**, by Francesco Moschino (d. 1578). Trained by his father Simone, Francesco carved his larger statues in a somewhat 17th century-like grandiose manner, whereas he reveals a truly Giambologna-inspired elegance in this kind of exquisitely modelled mythological relief. Here, Diana (for the Romans)

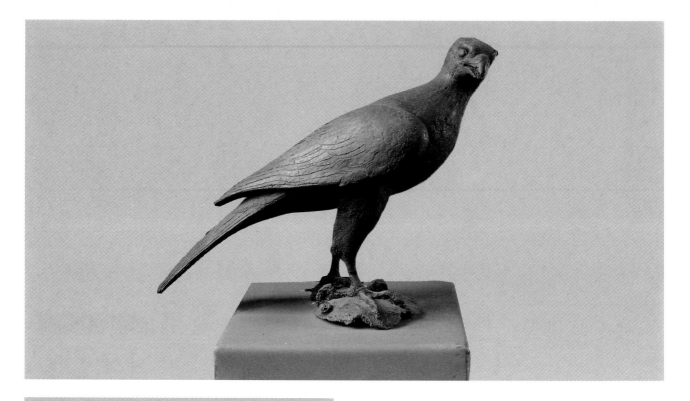

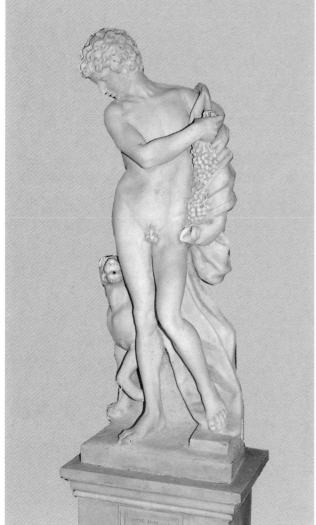

Hawk, by *Giambologna*; below left: **Bacchus**, 14th century Florentine School; below: **Greater Horned Owl**, by *Giambologna*.

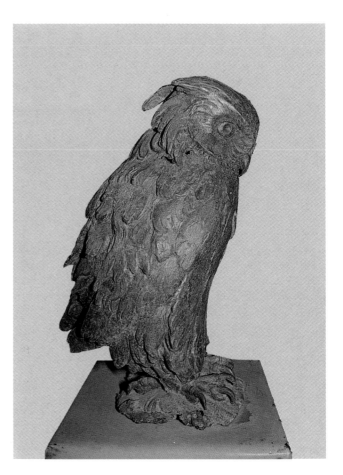

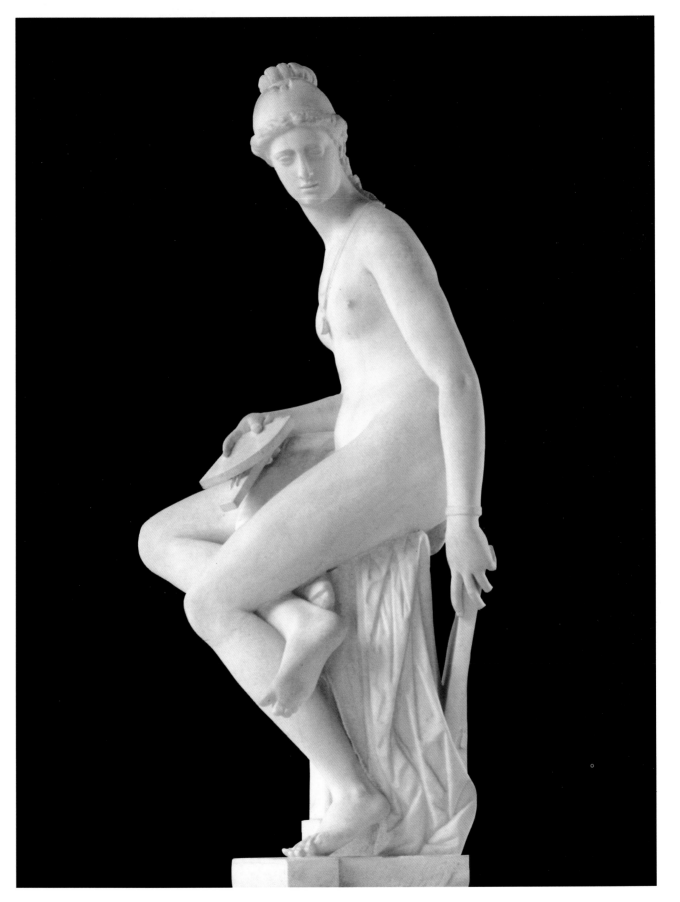

**Architecture,** by *Giambologna*.

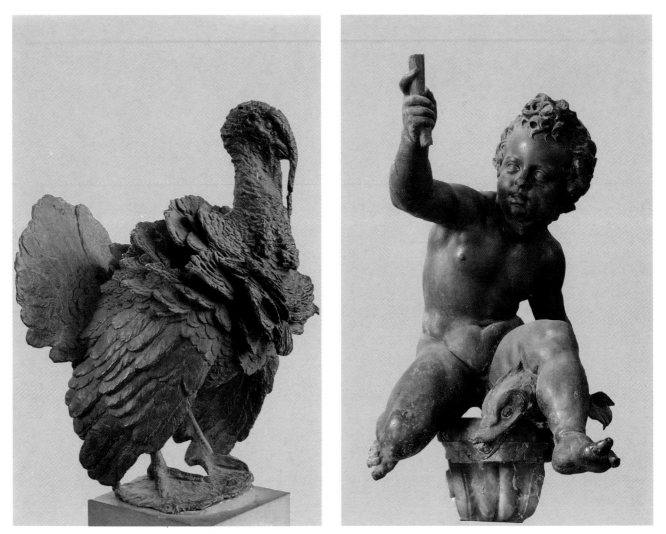

**Turkey** and, right: **Fishing Putto**, both by *Giambologna*.

or Artemis (for the Greeks), the Virgin Moon-Goddess, twin to Apollo, the Sun-God and daughter of Leda and Zeus, bathes in a glade in the forest (where as Lady of the Hunters, she reigns supreme),surrounded by her nymphs. Actaeon, grandson of Cadmus of Thebes, trained in the art of the chase by Cheiron, the centaur-tutor of the Argonauts, surprises her and/or (accounts vary) boasts of his prowess as a hunter, whereupon the goddess vengefully changes him into a stag, causing his own dogs to tear him apart.

**Bacchus**, marble statue of the Wine-God, holding a bunch of grapes, a panther at his feet, 16th century, Florentine.

**Two Medallions**, with profiles of Roman Emperors, in marble.

**Bacchus**, 16th century, Florentine marble statue.

**Pan and Olympus**, 16th century Florentine rectangular marble relief. Pan (the Pasturer), originally an Arcadic god of the hills and woods and protector of herds and hunters, was the inventor of the pan-pipes, that he is supposed to have made from a reed, into which the

nymph Syrinx is said to have changed herself to escape his hairy embraces. Much given to amorous pursuits, Pan whom the Romans also called Faunus (possessing, like Greek Pan, goat-like ears, horns and fleecy legs), or Priapus (the erotically aroused god of masculine potency and protector of fruitful orchards) would emit a shout, echoing through the wilderness, if disturbed during his midday rest, into which he was wont to sink during the sultry summer heat, that was said to engender "panic" terror, leading to headlong flight. Olympus, a pupil of Marsyas, was one of the mythical poets and musicians of the Phrygian legends and is supposed to be the founder of the art of playing the double-flute or aulos, so admired by Greeks, Etruscans and Romans. The two musical instruments, i.e.: the pan-pipes and the aulos, could be taken as the link between the two mythical figures.

**The Drunkenness of Noah**, rectangular marble relief, by Baccio BandinellI (Florence 1488-1560). An original piece, of refined virtuosity, unlike the majority of Bandinelli's work, where he seems to be almost obsessed by Michelangelo.

Mosaic portrait of **Pietro Bembo,** by *Valerio Zuccato* and right: **the south-eastern wall of the Sala Bruzzichelli.**

# THE BRUZZICHELLI LEGACY ROOM

(H – First Floor). This not very large room can be entered from the Terrace (or Verone), from the Maiolica Room or from the Ivories Room. It owes its present name to the Florentine antique dealer, Giovanni Bruzzichelli, who offered a number of objects from his collection (here exhibited) to the Bargello Museum.

Against the northern wall, three cases contain various glass objects, e.g.: a **Cask-shaped Bottle** and a number of **Vases** in milky-white blown and cut Venetian glass, 18th century; a number of Tuscan polychrome **Glasses**, **Vases** and **Bottles**, 18th century; two Venetian polychrome enamelled **Goblets**, 15th century; a 16th century Venetian calcedonia type glass **Aquamanile** and various **Scent Bottles** of the same provenance; a delicate 18th century **Bowl** decorated with clear glass and lattimo (milky-white glass made with lead) opaque twists (retortoli) and a number of **Chalices** and **Goblets** with covers, the Medici crest

engraved on the sides, Venice, 17th century.

See also two magnificent **Sacristy Credenzas**, carved with floral motifs and lion-claw feet (17th century), from the Church of San Michele in Carmignano; a great early 16th century **Table**, from the Demidoff Collection, with a gilded wooden Tuscan late 16th century **Tabernacle** standing on it, four early 16th century Tuscan walnut **Stools** with wooden backs; a 15th century marble **Bust of a Boy**; a 16th century polychrome marble **Bust of Alexander** and a great wooden statue of **St. Michael Archangel** (17th century?), all Italian. Upon the walls: **Madonna and Child**, polychrome impasto relief, by Jacopo Sansovino; a number of marble panels in relief, such as **Apollo** and **Venus**, by Antonio Lombardi; the **Labours of Hercules**, **Mutius Scaevola**, etc; moreover: an interesting mosaic **Portrait of Cardinal Pietro Bembo**, by Valerio Zuccato (1542). The latter belonged to a family of Venetian mosaic-layers who worked in the Basilica of San Marco. In order to achieve certain painterly effects in his mosaic panels, Zuccato used to apply his pigments directly, thereby arousing Giorgio Vasari's great admiration.

# THE MAIOLICA ROOM

(I – First Floor). Dedicated to the maiolica collection as from 1888. The contents was rearranged in special glass, mirror-backed cases in 1983. The collection now includes the original Bargello nucleus, pieces from Palazzo Davanzati, from the Ceramics Museum of Faenza and other sources, disposed in chronological and geographical order. On the walls, above the cases, left, two glazed terracotta roundels, surrounded by glazed garlands of terracotta flowers and fruit, depicting **St. Francis** and **St. Ursula**, by Giovanni della Robbia, as well as a fine **Garland** in glazed terracotta, bearing the crests and mottoes of the Bartolini Salimbeni and Medici families ("Per non dormire" — Diamond and Poppyseed-pods), by Luca della Robbia the Younger, in 1523. Above the cases on the right, a rectangular panel and two more roundels with blue *Cherubim* and *Armorial Crest*.

Maiolica differs from ceramic and other similar earthenware artifacts, in that its glaze, instead of being of the transparent type (i.e.: made of lead and silicate of potash), is opaque and white, owing to the presence of tin. The objects (jugs, plates, wine-jars, etc.) modelled in clayish or chalky marl and carefully dried, uniformly kiln-fired, etc., were then either dipped into a mixture of tin-based glaze or had the liquid poured over them. Once fired, the surface became a perfect base for further decoration. As the tin-glaze is stable in the re-firing kiln, the various pigments painted on it with paint-brushes or other instruments, sink permanently into the base, without blurring or shifting.

Starting from the left: early 14th century maiolica, with manganese purplish brown and copper green decorations, from Viterbo, Siena and Orvieto; vases and jugs, decorated with the *zaffera* oak-leaf pattern, with human figures and stylized animals, on a white ground and dark blue foliage in relief, Florence, 15th century; also a great **Basin** or **Dish for Ewer**, with leaf and network motif on the inner surface, Florence, early 15th century. Further on: a series of 15th century Faenza-ware, ornamented with the highly coloured and decorative *peacock-feather motif*. More Dishes, Drug-jars, Bowls and Cups, etc., from Faenza, Deruta, Gubbio, Venice, etc. see especially the **Twin-handled** 15th century **Wine Jar**, decorated with foliage and the *Medici Diamond Ring*; a **Dish**, with *Cardinal Medici Passerini's Crest* and the motto: "Viva", Deruta, 1540. The corner-case contains a great **Holy-Wine Jar**, decorated with foliage, wine-tendrils and Family Crest, Tuscan, 17th century. See moreover the multiform maiolica ware from the Fontana Workshop (Urbino) from Francesco I and Cardinal Ferdinando de' Medici's collections (1588), such as oblong dishes, flasks, ampoules, etc., richly decorated with biblical and historical subjects, etc. Further on: Drug-jars, marbled ewer-basins, dishes, drug-jars, etc. from Florence, Cafaggiolo, Montelupo, 16th and 17th centuries. The last cases on the right contain Faenza, Bergamo and Savona, etc. ware, of the 17th to 19th centuries, as well as some rare Hispano-Moresque maiolica of the 15th century, imported by Tuscan merchants from Valencia and Cataluña.

**Drug-jar or Albarello,** late 15th century, from the Marche; opposite: **Wall-tile with the Martyrdom of St. Sebastian,** Faenza, c. 1510.

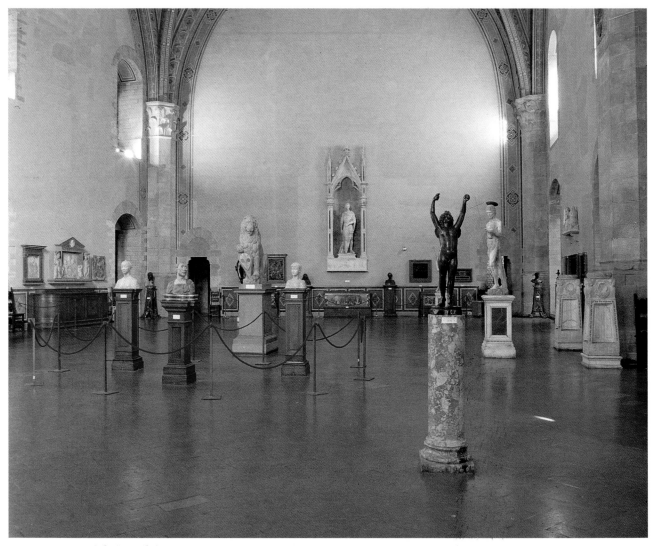

Partial view of the Donatello or Audience Hall; opposite: **Madonna of the Apple**, by *Luca della Robbia*.

# THE DONATELLO
# OR AUDIENCE HALL

(B – First Floor). Situated in the oldest part of the building, overlooking Via del Proconsolo, that was commenced in 1255 and restructured in 1332, when Benci di Cione opened the great south window. The other windows were opened a century later, upon the designs of Giuliano da Sangallo and Baccio d'Agnolo. It was divided into four orders of prison-cells as from 1574 and returned to its original appearance in 1857. To celebrate Donatello's fifth centenary, the great Audience Hall was dedicated to the production of the great artist and of the sculptors of his circle and inaugurated in 1888. Entering the hall via the door from the terrace, see from left to right:

**St. John as a boy**, natural terracotta statuette, by Michelozzo di Bartolommeo Michelozzi (1396-1472). A pupil of Ghiberti, he frequently assisted Donatello with his own particular brand of sober classicism.

**Madonna and Child**, painted terracotta relief in a gilded wooden cusped Gothic shrine with *Angels* and *Saints*; 15th century Florentine.

**Linen Press**, decorated in gilded gesso-work moulded allegorical figures in relief.

**Madonna of the Apple**, rectangular glazed terracotta relief, surrounded by gilded wooden frame, by Luca della Robbia, the base inscribed: AVE MARIS STELLA DEI MATER ALMA (1450-60). One of the great Renaissance innovators, Luca was a contemporary of Ghiberti, Donatello and Masaccio. In 1431, he worked on the great *Choirloft* for the Cathedral of Florence and on the five *Panels of the Liberal Arts* for Giotto's Belltower. Towards 1440 he started producing his famous coloured and glazed reliefs (blue backgrounds, white figures, framed by green and yellow garlands where the purity of his outlines express his serene humanity.

**Madonna and Child**, painted wooden relief on drop-shaped bracket, Tuscan, 15th century (?).

**Madonna and Child**, painted wooden relief, on rectangular bracket, Tuscan, 15th century (?).

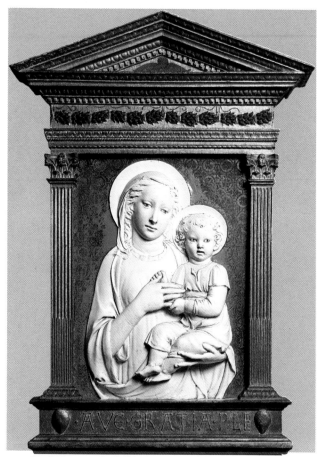

Madonna and Child, by *Luca della Robbia*; below:
Madonna and Child, by *Master of the Circle of Donatello or Michelozzo*.

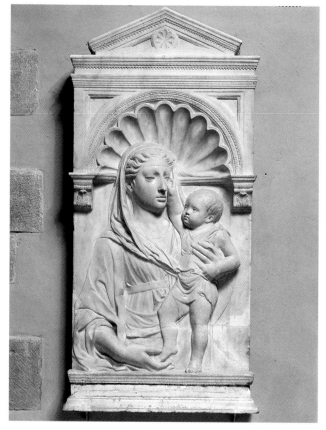

**Madonna and Child**, marble relief in round-arched niche, partly inlaid with blue enamel, in rectangular frame, by Michelozzo di Bartolommeo Michelozzi.

**Madonna and Child**, glazed terracotta relief in tympanum-topped gilded wooden frame, by Luca della Robbia.

**St. Peter freed from his cell**, marble panel in relief, by Luca della Robbia, for the Altar of St. Peter, in the Cathedral of Florence.

**Madonna and Child**, of the so-called "Genoese" type, in glazed terracotta, by Luca della Robbia.

**Crucifixion of St. Peter**, marble panel in relief, by Luca della Robbia, for the Altar of St. Peter, in the Cathedral of Florence.

**Holy Water Stoup Pedestal**, a marble baluster shaped bulbous column, on a triangular base, decorated with *Caryatids, Harpies and Rams-heads*.

**Madonna and Child**, painted terracotta relief in a gilded wooden frame, by the Master of the Pellegrini Chapel, first half of the 15th century.

**Bust of a Lady**, glazed terracotta, by Luca della Robbia's Workshop.

**Madonna and Child**, marble panel in relief in a round-arched, scallop-shaped niche, surmounted by small tympanum, by Artist of the Circle of Donatello or Michelozzo; donated by the Marquis Migliore Torrigiani.

**Madonna and Child with Two Angels** (1450), a splendid glazed terracotta roundel, surrounded by a garland of daisies and marigolds, by Luca della Robbia.

**Madonna of the Rose Garden**, rectangular glazed terracotta relief, painted blue, white, green, yellow and purple, upon a blue and white bracket. One of Luca della Robbia's most bewitching creations.

**Madonna and Child**, unglazed terracotta relief within a round-arched, scallop niche, by Artist of the Circle of Donatello or Michelozzo (bequeathed by Countess Harriette della Gherardesca).

**Effigy of Mariano Sozzino Seniore**, a recumbent bronze statue, upon a wooden chest, by Lorenzo di Pietro, known as Vecchietta (1412-1480). It was cast in 1467 as a memorial to be placed in San Domenico in Siena. The artist, influenced in his painting by Sassetta and in his sculpture, by Donatello and his Circle, is also supposed to have worked with Masolino, on the Castiglione Olona frescoes (1435); he was also active in the Hospital of Santa Maria della Scala and in the Baptistery, both in Siena.

**St. John the Baptist**, bronze satuette, Italian, 15th century.

**Madonna and Child**, rectangular marble relief with blue enamel decorations, from the Workshop of Donatello, 15th century; once in Villa Goretti in Campoli, Val di Pesa.

**Linen Press**, Tuscan, 15th century, the front decorated in gilded gesso reliefs.

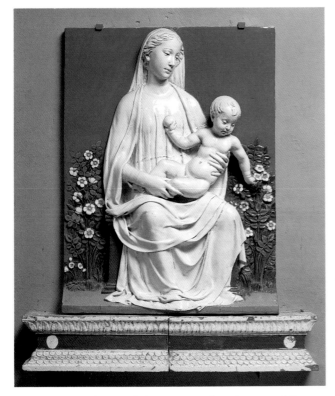

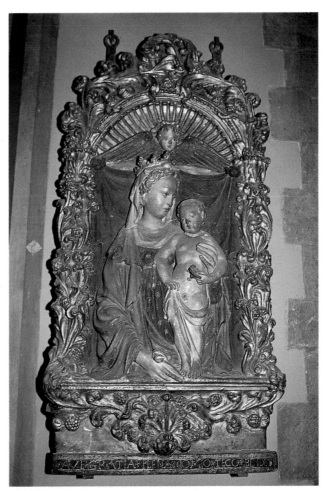

Above: **Madonna of the Rose Garden,** by *Luca della Robbia*; right: **Madonna and Child,** by the *Master of the Pellegrini Chapel*; below: **Madonna and Child with Angels,** by *Agostino di Duccio*.

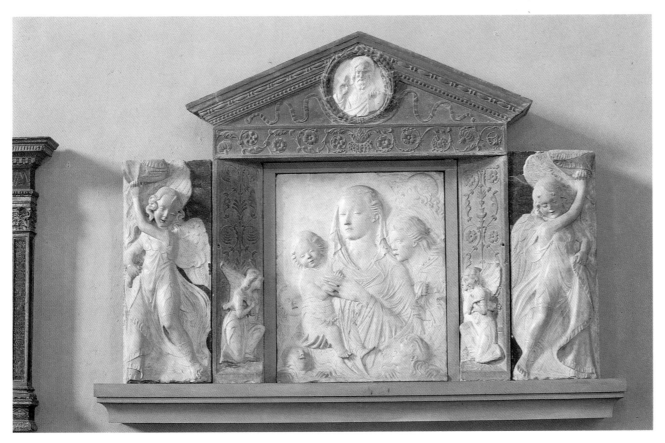

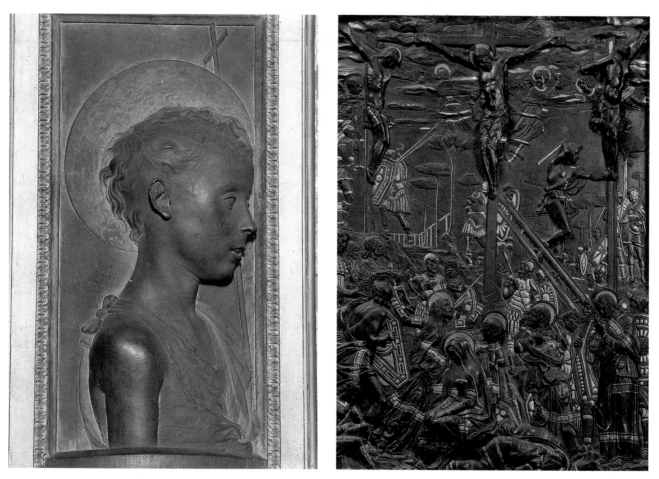

**St. John the Baptist as a Boy,** by *Desiderio da Settignano* and **Crucifixion,** by *Donatello.*

**Four Column Pedestals,** in marble and decorated with cherubs and scallops, from Donatello's Workshop, 15th century; transferred to the Bargello from the Tuscan State Deposits.

**David,** by Donato di Niccolò di Betto Bardi, known as Donatello (1386-1466). A 191 cm.-high marble statue, upon a great red and white marble plynth, sculpted around 1408-9, when the sculptor was working with Nanni di Banco on the Cathedral of Florence. An early work, still bound to Gothic stylemes.

**Madonna and Child,** marble relief in gilded wooden frame, by Desiderio da Settignano (1430-64). From the shrine on the Canto (corner) de'Martelli, where Desiderio and his brother Geri had their workshop (in the mansion of their rich protector Antonio Panciatichi). Probably apprenticed to Donatello in his youth, Desiderio achieved considerable renown at an early age and was so overburdened with commissions, that he refused to carve a *Madonna* for powerful Francesco Sforza. This work shows the artist's taste for a Donatellian-type of "schiacciato" (extremely low) relief, that he carries out here with a truly lyrical touch. His tenderly delicate plasticism, and his almost painterly light and shade effects however lack Donatello's stalwart, heroic tones.

**Madonna and Child with Angels,** by Agostino di Duccio (1418-c. 1481). A complex work, with a central marble relief, surrounded by a grey sandstone niche, with a medallion of the *Almighty* in the tympanum and *Angels* and *Cherubs* on the side-jambs. Probably an altarpiece, from Santa Maria del Carmine, in Florence. Trained as a goldsmith, Agostino was banished from Florence for having committed a theft, in 1441. He worked in Modena, Venice and in 1449-55, on the Malatesta Temple in Rimini, where he carved his famous *Angel Musicians* and the *Liberal Arts* that gave perfect expression to the humanistic atmosphere at the Malatesta court.

**Inlaid wooden Sacristy Cupboard,** Tuscan, 15th century.

**Madonna and Child with Angels,** by Agostino di Duccio, rectangular coloured terracotta relief, commissioned by the Salutati family, at that time the owners of Villa di Petraia.

**Bearded male head,** bronze, attributed to Donatello. Highlighted in gold leaf, upon a carved base, its dramatically classical style has a number of points in common with various works of the artist in his maturity.

**St. John as a Boy,** by Desiderio da Settignano, attributed in 1784 to Donatello.

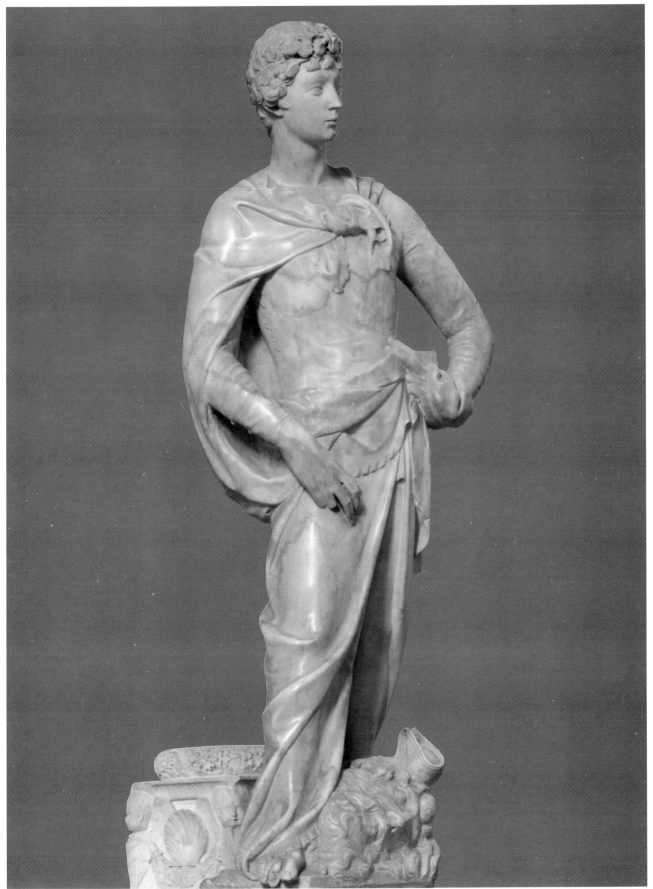

**David,** by *Donatello*.

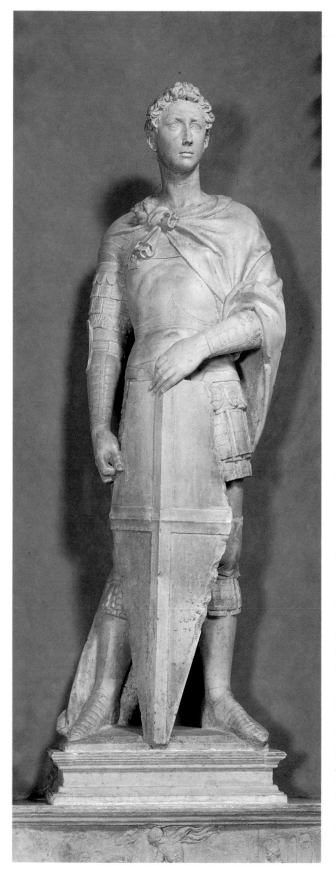

**St. George** and opposite: **David**, both by *Donatello*.

**Crucifixion**, bronze relief with golden highlights, by Donatello, known also as the *Medici Crucifixion*, it was listed in Raffaello Borghini's inventory of Francesco I's possessions in 1584. Pope-Hennessy dates the work around 1453-56.

**Dower Chest**, with front painted with the *Stories of Saladin and Master Torello*, from a story by Boccaccio, Florentine, 15th cent.

**David**, bronze nude, by Donatello; the youth wears shin-guards or greaves and a hat crowned with laurel, his left foot resting upon the chopped-off head of *Goliath*. Cast between 1430 and 1440, the figure is yet another example of Donatello's illogical fancy and daring classicism. This first Renaissance nude, represents the biblical hero as a praxitelian demi-god, his musing visage brimming-over with Etruscan irony. The laurel wreath and the seven spheres on the Medici crest beneath the famous statue, support the hypotheses that it was commissioned by Cosimo de' Medici the Elder, for the courtyard of Palazzo Medici, where it in fact comes from.

**Portrait of an unknown Lady**, Florentine, 15th century, once attributed to Donatello.

**St. George**, marble statue within a Gothic cusped niche, with marble predella beneath it, in low relief, by Donatello. The statue, commissioned by the Armourers' Guild, in 1416, was a veritable manifesto of the new sculpture of the Renaissance. The predella relief showing *St. George slaying the Dragon to save the Princess of Cappadocia*, is one of the first instances of Donatello's renowned "schiacciato" (very low relief) technique, whereby he depicted a landscape with trees bowed by the wind, dwindling into the background, in a few inches of marble.

**Dower Chest** in gilded and painted wood decorated with the *Procession of the Banners of St. John*, Florentine, 15th century. It is interesting to note that the porphyry columns with the Chains of the Pisan Harbour stood at that time between the Baptistery and the Cathedral.

**Bust of a Youth**, in bronze, attributed to Donatello.

**Crucifixion**, by Bertoldo di Giovanni (c. 1420-91); bronze relief in a marble frame; a youthful work of the artist, who was apprenticed to Donatello in 1455 and was influenced by the latter's maturer style, inasmuch as he assisted his master when he was working on the *Pulpits* of San Lorenzo. In 1488 he became the Superintendent of the Magnificent Lorenzo de' Medici's Antique Sculpture Collection in the Gardens of San Marco, where young Michelangelo came to learn the art of sculpture.

**Dower Chest**, in wood, painted with the *Expedition of the Argonauts*, Florentine, 15th century.

**Christ Deposed** or **Man of Sorrows** and **Triumph of Bacchus**; two small bronze reliefs, by Bertoldo di Giovanni, where a formal realism and violently agitated

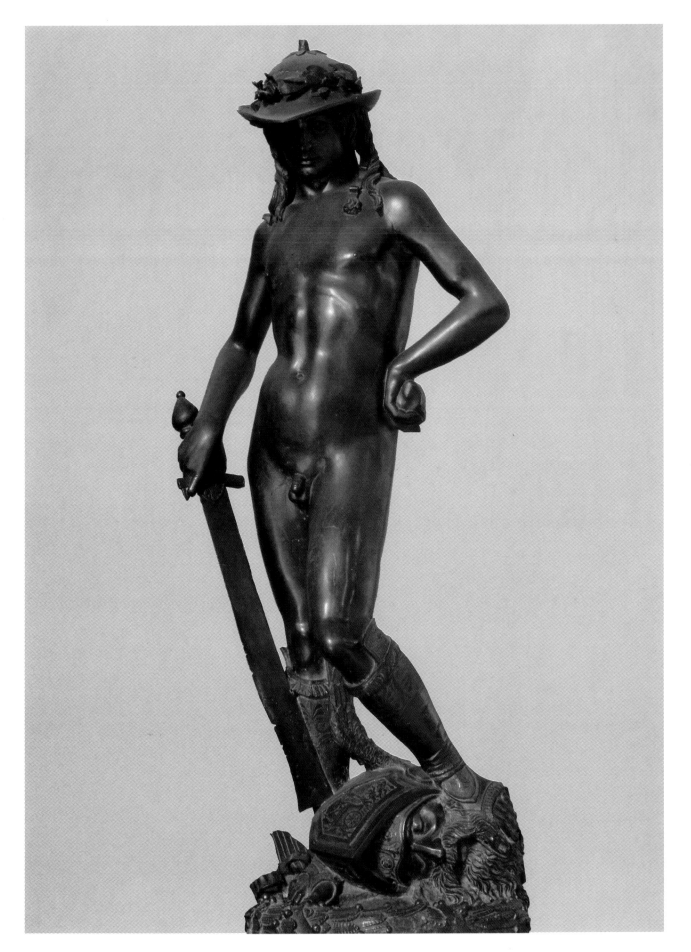

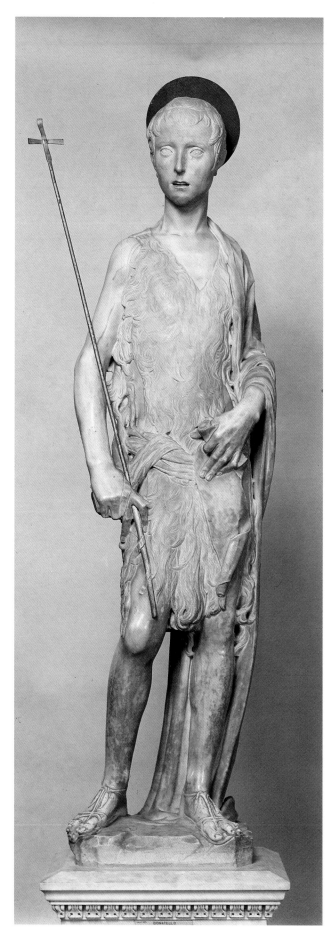

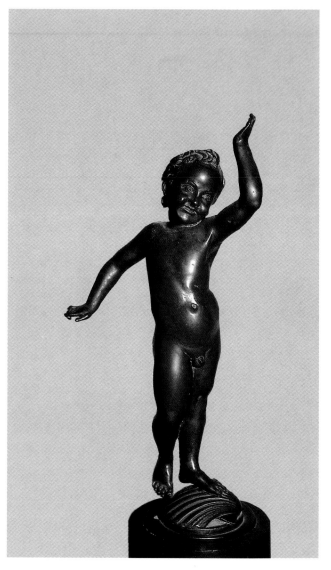

Above: **Dancing Putto,** by *Donatello*; left: **St. John the Baptist as a Boy,** by *Desiderio da Settignano*.

expressionism reveal Donatello's influence.

**Roman Emperor**, from Donatello's Workshop, once in the Grand-ducal Collections.

**Orpheus**, bronze statuette, by Bertoldo di Giovanni. The rapt nude figure of the mythical poet plays a rebeque or fidula-like lute.

**St. John as a Boy**; this delicately modelled marble statue by Desiderio da Settignano, once attributed to Donatello, comes from the Martelli Mansion.

**Abraham and Isaac**, bronze quatrefoil panel in relief, by Filippo Brunelleschi (1377-1446). The great architect started-off as a goldsmith and sculptor, travelling to Rome in 1402, together with his friend Donatello, to study the art and architecture of the Ancients. This panel won the competition for the *Doors* of the Baptistery, ex-aequo with Lorenzo Ghiberti's (1401), but Brunelleschi decided not to work with Ghiberti on the

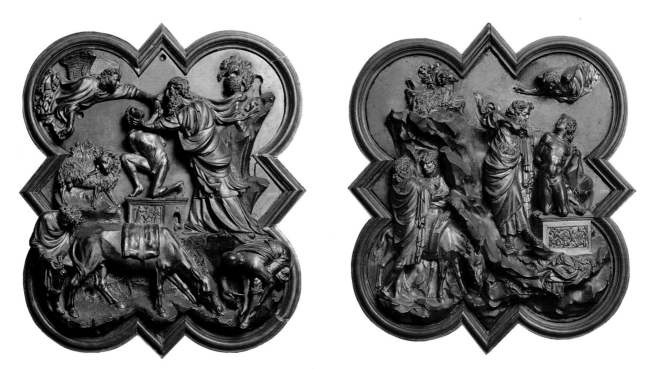

**Abraham and Isaac,** by *Filippo Brunelleschi* and right: **Abraham and Isaac,** by *Lorenzo Ghiberti*.

famous Doors (and only resumed sculpture in 1420, when he carved the noble *"Egg" Crucifix* for Santa Maria Novella), concentrating on his project for the Dome of the Cathedral of Florence.

**Battle between Romans and Barbarians**, bronze relief, by Bertoldo di Giovanni.

**Abraham and Isaac**, bronze quatrefoil panel in relief, by Lorenzo Ghiberti (1378-1455). A brilliant sculptor, architect and writer, Ghiberti started-off as a goldsmith. He too competed for the project of the Baptistery Doors, in 1401 and won ex-aequo with Brunelleschi, thanks to this panel, which together with Brunelleschi's, used to be in the Medici collections. The Baptistery Doors, that he cast after his victory in the competion, were divided into 28 panels, illustrating *Episodes from the Life of Christ*, the *Four Evangelists* and *Four Fathers of the Church* (1403-24). Its quatrefoil panels recall the quatre-foil frames Andrea Pisano used for his *Doors*(1330-36), illustrating *Episodes from the Life of St. John the Baptist* and *Eight Virtues*.

**Annunciation** (1491), by Nicola di Guardiagrele (active in Abrutium, late 14th-early 15th century). Nicola was a goldsmith and sculptor, bound to the local Gothic tradition, until he encountered Lorenzo Ghiberti's work.

**Reliquary Urn**, in bronze, by Lorenzo Ghiberti, commissioned by Cosimo and Lorenzo de'Medici, in 1428, when the artist was working on the third set of *Doors* for the Baptistery (the *Paradise Doors*). The urn, with its classically graceful decorative motifs, is also known as the *Urn of the Three Martyrs*.

**Dancing Putto**, small bronze statuette, by Donatello; a classical theme, interpreted with lively realism, by this great artist.

**Madonna and Child**, by Antonio di Chellino da Pisa, natural terracotta relief in round-arched niche.

**St. John the Baptist**, life-size marble statue, from Donatello's Workshop of the youthful, emaciated saint, consumed by penance and starvation.

**Madonna and Child**, great natural terracotta wall-statue, Florentine, 15th century(?).

**Madonna and Child with Angels**, a splendid glazed lunette, by Luca della Robbia, surrounded by a garland of lilies; from the Monastery in Via dell'Agnolo, in Florence.

**Adoration of the Child**, coloured and glazed terracotta relief, by Luca della Robbia, with the *Mother* adoring the *Child* and *Angels* singing praises in the rounded upper portion of the panel.

**St. Bernardino of Siena**, painted wooden statue (1457-61?), by Lorenzo di Pietro, known as il Vecchiet-ta. The saint, bearing the *Monogramme of Christ* in the flaming *Sun-Disk*, standing upon a circlet of angels; beneath which: the artist's name (Opus Laurentii Petri Pictoris Senensis).

**Marzocco**, grey sandstone statue, by Donatello: a lion sejant, his right fore-paw raised to protect the Florentine lily, emblazoned on a shield. Carved in 1418-20 for the loggia of the Papal apartments in Santa Maria Novella, and transferred later to the podium in front of the Town Hall (where its reproduction stands today) and thence to the Bargello. The name "Marzocco" derives from *Martocus* (little Mars), a statue of the Roman war-god, which was placed in Roman times at the end of the Ponte Vecchio (Old Bridge), to protect the town (founded by the sons of Mars: Caesar's veterans) and dedicated to the goddess of fruitfulness, Flora, whose

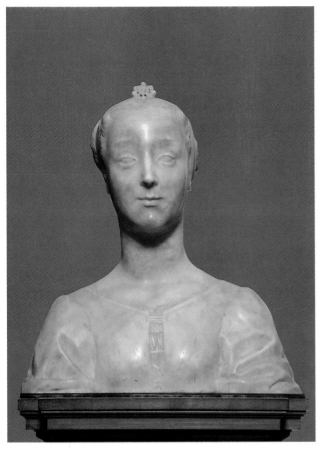

**Portrait of a Young Lady,** by *Desiderio da Settignano* and below: **Niccolò da Uzzano,** by *Donatello*.

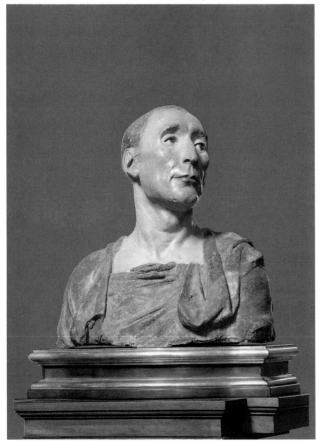

symbol, like the Christian Mother's, was the lily whence, probably, the Latin name of the colony: Florentia (?). The *Martocus* statue was swept away by the 1333 Arno river floods and later replaced by a statue of the animal sacred to him: the lion, protecting the symbol of the goddess, later adopted as heraldic charge of the town.

**Portrait of a Boy**, a marble bust, by Desiderio da Settignano.

**Niccolò da Uzzano**, painted terracotta portrait bust, by Donatello. One of the sculptor's most famous and powerful portraits. Born in Florence in 1359, Niccolò da Uzzano was one of the Ten, then he was elected to the Balìa and was thrice Gonfaloniere of Justice. He attempted to unite the oligarchy led by the Albizzi family against the growing power of the Medici, dying in Florence in 1431. The bust comes from Palazzo Capponi, in Via de' Bardi, once the property of Niccolò da Uzzano.

**Portrait of a Young Lady**, marble bust, by Desiderio da Settignano. The youthful grace of the girl's features reminds one yet again of the psychological ability, described by Giorgio Vasari as "a sweet and charming manner", that this artist, who was only thirty-four, when he died, so noticeably possessed.

**Eros**, bronze statue, by Pier Jacopo Alari Bonacolsi, known as the Ancient (Mantua c. 1455-1528). Both sculptor and goldsmith, the artist cast numerous bronze statues for the Gonzaga family, deriving most of his figures from classical models.

**Attis-Amor**, an enchanting bronze figure, by Donatello. It was commissioned by the Doni Family and entered the Medici collections in 1778. For quite a considerable length of time, it was thought to be an Etruscan statue. Attis, the Phrygian god of vegetation was, according to Diodorus, the lover of the Great Mother, Cybele and was killed by her father. Cybele than roamed the desolate earth (winter) until her father granted new life to her lover (spring). The poppy heads on Attis' belt are in fact simbols of the Earth Mother, the One and the Many, Pregnant and Virgin, emblems of fruitfulness (the swelling pods) and of forgetfulness. The writhing serpent at the boy's feet is a ctonian symbol, of life buried and reborn, always associated with Cybele, Attis' nurse and lover. The godling's head-dress and breeches held-up by a belt, in the Phrygian manner, remind one of the Anatolian origins of the Cybele and Attis cult. The detailed iconographic knowledge, revealed both here and in Donatello's Dionysiac dance carved on the *Choirloft* he made for the Florentine Cathedral, is a further reminder of his abiding passion for the ancient world. The exposed genitals of the young god probably recall the ritual eviration to which the priests of the Attis cult subjected themselves. In this statue, Donatello seems to have compounded elements from the Phrygian god, the Greek Eros (the wings) and potent Roman Faunus (the goat-like tail).

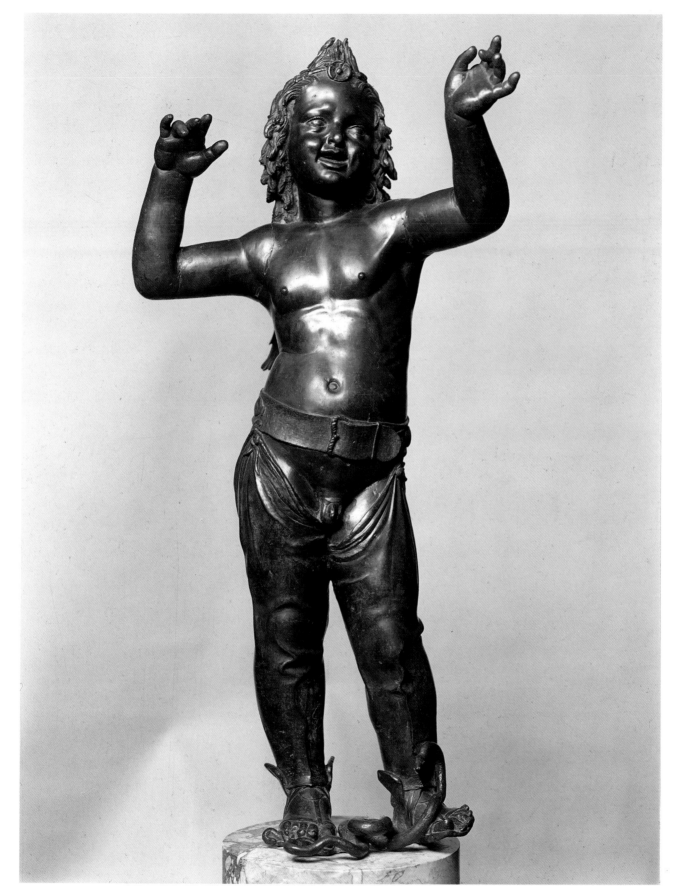

**Attis-Amor,** by *Donatello*.

# THE ISLAMIC ROOM

(C – First Floor). Since 1982, this room has contained eleven cases of artifacts, maiolica, metalware and arms of Islamic provenance, from the Carrand, Franchetti and Ressman legacies, as well as from the Grand-ducal collections and other sources. On the walls, donated by Luigi Pisa (1933): a number of Anatolian **Rugs** woven with symmetrical knots, of the 16th to the 17th centuries, from **Ushak**, of the *Holbein Star*, *Flowers and Birds* and *Lotto* types. The ancient linen and silk **Brocades** from Central Asia (7th-8th centuries), Spain and Egypt (10th-12th centuries), in the cases on the left, were donated by Baron Alessandro Franchetti in 1906. The Islamic collection includes arms and armour and parade accoutrements of various provenances, such as, for instance: a velvet, brocade, gilded brass and iron **Jacket** (Egypt, 1438), from the Grand-ducal collection; three 15th century beaten and damascened iron **Helmets**, from the Imperial Armoury of Istanbul at St. Irene, one with the Sultan Mahomet II's symbol (1452-80) and an iron **Mace**, damascened in gold (Persia, 17th century). Another case contains a great brass **Water-ewer**, damascened in gold and silver, of Mameluk provenance (Egypt 1363-1377); in another case: a rare **Syrian Dish** beaten, engraved and damascened (4th century), with a rosette and two European family crests in the middle; a rare bronze **Mirror** (Persian, 11th to 12th century); in the next case: Islamic ivories, mostly from the Carrand legacy, such as a marvellously carved and jewel-encrusted ivory **Casket**, mounted in gold and silver, Omayad art, Spain, 10th/11th century and a series of **Chess-pieces** (Irak, 9th-10th centuries). In the maiolica case, see the Persian **Star-shaped** Kashan metal-lustre **Tiles** of the 13th-14th centuries, from the Carrand legacy, as well as a rare, turquoise-glazed **Elephant-shaped Aquamanile**, Persian, 17th century. The cases in the middle of the room contain, amongst other items: a great spherical **Censer** (Syrian, 16th century); a magnificent **Mosque Lamp**, in enamelled glass (Syria, 1345); a remarkable brass **Bowl**, damascened in gold and silver and decorated with the *Sun* and the *Signs of the Zodiac* (Syria 16th century); see moreover: a famous engraved bronze **Vase**, damascened in silver, Syria, 1259.

Above: **Lotto-type** 16th century **Ushak Rug**; below: silver and gold damascened brass **water Ewer** of 14th century Mameluk Egyptian provenance.

**Head-rest for a bed-stead**, by *Alessandro Allori*; below: 13th century Limousin **Reliquary Casket** in wood and enamelled copper, with pyramid-shaped lid.

# THE CARRAND LEGACY ROOM

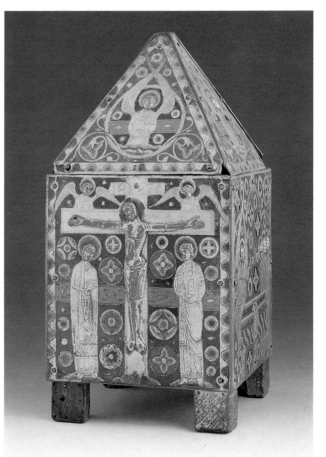

(D – First Floor), known as the *Room of the Duke of Athens*, because of the latter's crests, which adorned its windows, or of the *Podestà*, as it was once the Audience Chamber of the Podestà. Since 1888, it has contained the Carrand Legacy, donated by the antiquarian Louis Carrand (from Lyons, in France) to the town of Florence, as recalled by the inscription beneath the **Portrait Bust** of the generous collector, by Italo Vagnetti, in the room. On the walls: a number of panel paintings, that reveal both Louis Carrand and his father's admiration for European Medieval and Renaissance painting. See, for instance: **Death tries to hold back Youth**, by Hans Baldung, known as Grien (1484-1545), a pupil of Dürer; the **Martyrdom of St. Ansanus**, by Giovanni di Paolo (1400-1482); **Madonna feeding her Child**, the **Saviour** and **St. Anthony Abbot**, by Agnolo Gaddi (IInd half of the 14th century) and the famous *Carrand Diptych*, with the **Coronation of the Virgin** and a **Noli Me Tangere**, by the Master of the St. George Codex, of the Circle of Simone Martini. Moreover: **Christ in Limbo** and **Resurrection of Christ**, by Marcellus Coffermans, 14th century; a **Head-rest for a Bed-stead**, decorated with grotesques against a golden ground, by Alessandro Allori (1572); in the middle of the room: **Annunciation** and **Presentation at the Temple**, a diptych by the Master of the Legend of St. Catherine (Brussels, 1460-c. 1500) with a

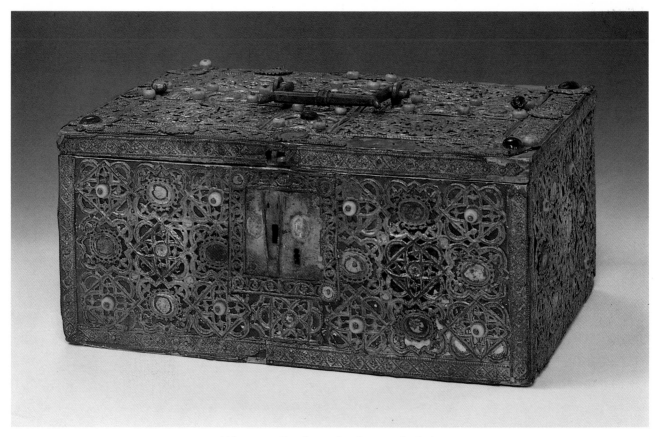
16th century French wood and copper **Casket.**

**Madonna and Child** and **St. John the Baptist** in "grisaille" on the outer sides of the panels. On either side of the Chapel door: **Announcing Angel** and **Annunciate Virgin**, two painted wooden statues, Pisan, 14th century.

The prodigious collection is arranged in 19 cases and includes **astronomical instruments**, **door-knockers**, **locks**, **keys**, **clocks** and **watches**, **surgical instruments**, **knives**, **table-ware**, etc. See, for instance: a Franco-Flemish **Money Bag** in iron and embroidered leather, of the 16th century; late-Roman **Painted Glass** objects; a 15th century German **Hunting Horn**; a series of statues and statuettes of the *Madonna and Child* of various materials and provenances. Of the many "Wunderkammer" curiosities, see a bronze **Homo Silvanus Candlestick** representing a wild man of the woods clothed in plaited hair, German, 16th century, or the bronze **Fountain Finial** in the shape of a naked woman on a sphere covering her genitals with her hands and the inscription "UBI MANUS IBI DOLOR", German, 16th century. Further on: the spectacular Flemish, French (from Dinant) and German 14th and 15th century **Acquamaniles**, such as the one in the shape of *St. George on horseback* slaying a little dragon trying to crawl up the horse's rear leg (1400-40) from the Mosan/Rhineland area and a remarkable **Armillary Sphere** of the 16th century. The collection continues with a series of **liturgical gold and silver objects**, **tomb jewellery**, **parade ornaments**, etc., enamelled and decorated with gems, of Byzantine, Longobard and Frankish provenance of the 6th and 7th centuries, such as the **Plaque from King Agilulfus'Helm** and a golden leaf **Cross**; the series of **Frankish Fibulae**, donated by Otto of Hessen; the **Byzantine Jewellery**, including golden ornaments decorated with gems, pearls and coloured glass paste, reminiscent of the jewels depicted in the Byzantine mosaics in Ravenna; a number of antique intaglios, such as a **St. George in Armour**, in sardonyx, of the 10th/11th centuries. The famous enamels in the Carrand Collection exhibited in this room and in the neighbouring *Chapel* and *Sacristy*, perfectly illustrate the various techniques whereby one used to apply vitreous paste to the surfaces of metal objects, by melting the paste. The basic procedures were the *cloisonné* method, which consisted in filling small cavities, bordered by metal fillets or twisted wires; the *champlevé* method, where the glass paste fills a series of cavities hollowed out of the metal sheet itself; the *translucid* enamel method, in which a thin layer of vitreous paste is spread over an engraved or sculpted surface and the *painted* enamel method, in which the vitreous paste colours are painted directly onto a metal surface or onto a white enamel base, with a brush. The use of vitreous paste was extremely widespread since

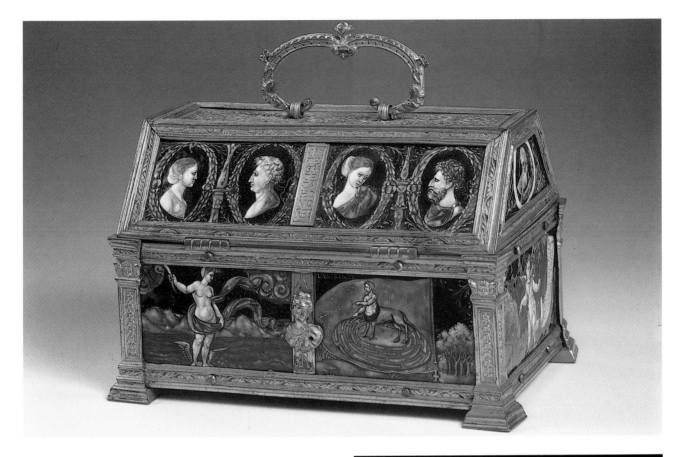

16th century French enamelled **Reliquary Casket**; right: **Prelate**, enamelled copper portrait plaque, by *Léonard de Pénicaud of Limoges*.

the most ancient times. *Champlevé* enamelled objects dating from the 1st millennium B.C. have been found in Caucasian tombs. *Cloisonné* enamelled items were manufactured in ancient Greece, Persia, Asia Minor, the Scythian territories, Etruria and ancient Rome. Byzantine artists used both the *cloisonné* and *champlevé* methods, spreading this type of decoration all over Europe: an instance of this type of decoration is the great *Golden Altarscreen* in St. Mark's Basilica in Venice (11th century). The Mosan, Rhineland and Limoges areas produced the most splendid examples of this kind of art around the 12th and 13th centuries. The Limoges artists achieved splendid heights of virtuosity in the 16th century, specially when Léonard (or Nardon) de Pénicaud produced his brilliantly coloured enamels. See for instance: a Limousin **Reliquary Casket**, c. 1230, in wood and enamelled copper, with a pyramid-shaped lid, the sides decorated with the *Crucifixion* the *Holy Women at the Sepulchre*, the *Virgin* and *St. Paul*; **St. Martial**, a gilded and champlevé enamelled copper plaque, c. 1230, made, like the similar one at the Louvre, for an altarpiece in Limoges, in the 13th century; four round enamelled bronze **Bosses**, decorated with animal figures, made for Boniface XXIX, abbot of Coques around 1120; two splendid **Croziers**, one in gilded and enamelled bronze by Willelmus, in England in 1175; thereafter: a number of Rhineland and

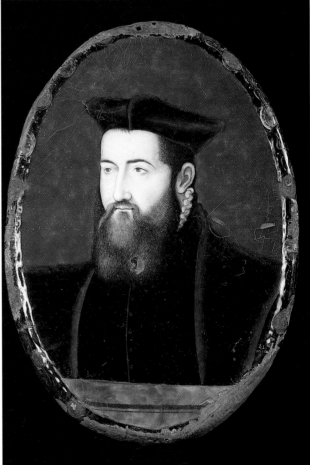

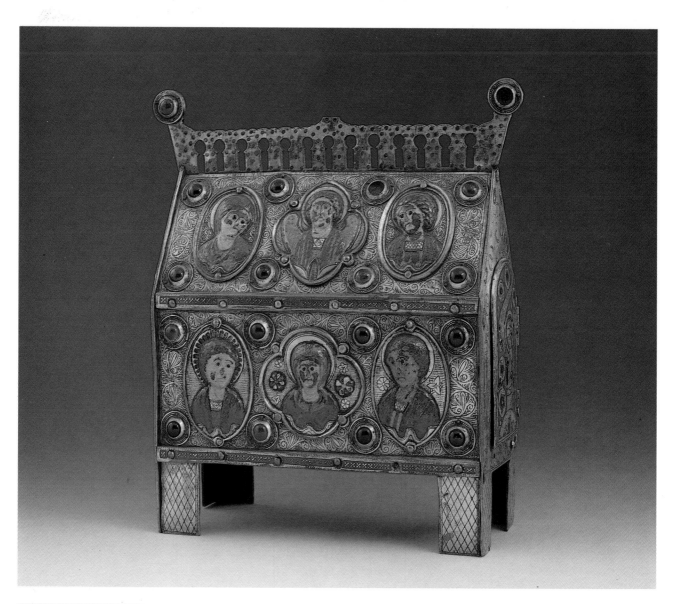

13th century Limoges enamelled copper **Reliquary Casket**; left: two Flemish bronze **Flagons**, 16th century.

Mosan **Plaques** of the 12th century, a **Reliquary Pedestal**, a **Candlestick**, a **Dove-shaped Pyx** and four **Psalter-binding Plaques** in silver gilt and champlevé enamel, with the symbols of the Evangelists, of Mosan art, c. 1160. Among the enamelled liturgical Gothic style objects, see the great silver-gilt and enamel trident-shaped **Crucifix**, with a *Cross* on the central tine and the *Madonna* and *St. John* on the side-tines (France, 14th century). Among the Renaissance items, note the magnificent Limoges painted enamel objects, by Léonard or Nardon de Pénicaud (Limoges, 14th-15th centuries), e.g.: the great oval plaque with a portrait of a **Prelate**; the little plaque with the bust of the **Redeemer**; the triptych, with the **Man of Sorrows**, flanked by the **Madonna**, **St. John**, **St. Peter** and **St. Paul**; moreover: a **Noli Me Tangere**, with a *Magdalen* in oriental costume.

Partial view of the Chapel of St. Mary Magdalen or of the Podestà.

# CHAPEL OF ST. MARY MAGDALEN OR OF THE PODESTÀ

(E – First Floor). East of the Carrand Room, three steps lead up into the Chapel of St. Mary Magdalen or of the Podestà, where, until the 18th century the prisoners condemned to death spent their last hours in prayer, assisted by the Brethren of the Company of the Black Friars (Neri), sometimes consuming a "small oil-cake of three ounces", baked by the nuns of the Convent of San Niccolò. Above the entrance to the Chapel a relief of the **Madonna and Child**, with the **Podestà kneeling in prayer** (to the right). The four-sided interior, with its barrel-vault, once divided up into prison-cells and store-rooms, returned to its original appearance in 1839, when Antonio Marini was commissioned by the Tuscan Government to bring the original frescoes concealed by the white-washed plaster back to light. Opposite the entrance, the artist (of the Workshop of Giotto?) depicted **Paradise** with a number of recognizable personalities in the right lower section, such as Dante Alighieri, and according to some, Corso Donati

and Brunetto Latini or king Robert of Anjou of Naples and Cardinal Del Poggetto. Dante appears to be about thirty years old, as he must have been, when Giotto knew him. Lumachi, in his guide-book on Florence, tells us that Dante was originally clothed in red, white and green and that his robe was later painted a brownish colour, in 1849, for political reasons. Above the entrance wall, there is a frescoed **Inferno** (or Hell); on the side-walls: the **Stories of Mary Magdalen**, **St. Mary of Egypt** and **Christ** (*St. Mary of Egypt is blessed by Bishop Zosimus*; *Bishop Zosimus gives her Holy Communion*; *an Angel brings her a flask, while she is praying*; *Jesus and the Magdalen*; *the Maries at the Sepulchre*; *Resurrection of Lazarus*; *Christ and Simeon*; *Dance of Salome*; *the Miracle of the Merchant of Marseilles*). Beneath the fresco of Paradise, to the left: rectangular fresco of **St. Jerome**; right: frescoed roundel with **Madonna and Child**, both by Sebastiano Mainardi (1490). The **Choirstalls** and the great **Lectern**, marvellously inlaid by Bernardo della Cecca for San Miniato al Monte, come in effect from the Convent of San Bartolommeo a Monteoliveto Minore. Protected by sheet-glass, against the end-wall: **Madonna and**

Madonna and Child and Podestà kneeling in adoration, by *Alberto Arnoldi*; left: **detail of Paradise, with alleged portrait of Dante Alighieri**, by *Master of the Giotto Workshop*; below: **Madonna and Child**, by *Sebastiano Mainardi*.

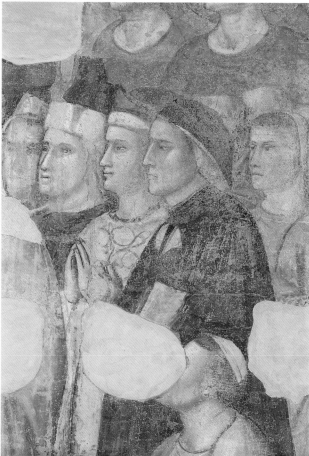

**Child with four Saints**, a triptych by Giovanni di Francesco (1428-1459) and enamelled **Altar-step**, by Andrea Pecci da Empoli (1313); in front: a case with 13th-16th century reliquaries, censers, etc. On either side: **Bronze Candlestick** with Medici crest, by Valerio Cioli (1529-99) and **Bronze Candlestick** with the Guelph Party crest, Tuscan, 16th century. At the other end of the Chapel, near the entrance, two long cases house an important collection of liturgical artifacts from the 14th to 16th centuries. In the right case, see an Ambrosian **Monstrance**, Florentine, 15th century: a **Pax**, attributed to Antonio di Salvi, from the Opera del Duomo in Florence; a number of Sienese and Florentine **Reliquary Crucifixes** of the 15th century; a Tuscan **Paten** of the 15th century, from San Niccolò di Calenzano; a parcel gilt Florentine **Reliquary Bust of St. Ignatius**, attributed to Antonio di Salvi, 15th century, from the Basilica of Santa Maria Novella, as well as a series of **Chalices**. The considerable number of nielloed objects in the chapel remind one of this goldsmith's technique, that consisted in filling lines, etched onto a gold or silver sheet, with a black mixture (*nigellum*), made of red copper, silver, lead, sulphur and borax. The left case contains a number of nielloed and enamelled Venetian and Lombard **Paxes** of the 16th century; a splendid bronze, silver and golden Venetian **Reliquary Cope** of the 16th century, as well as **Chalices**, **Goblets**, nielloed and enamelled **Plaques**, with apostles, prophets, etc. of various provenances and periods. The neighbouring **Sacristy** is a small square room with

15th century Florentine **Reliquary Bust of St. Ignatius;** below: 16th century Venetian **Reliquary Cope.**

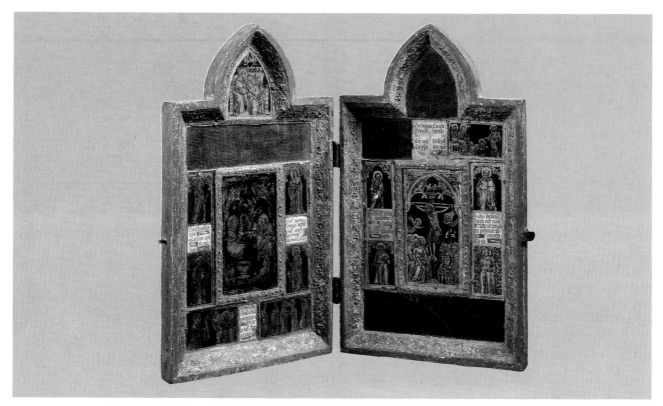

14th century Umbrian nielloed **Diptych;** below: 15th century Parmese enamelled **Pax** with jewelled frame of later date.

feigned marble wall decoration and four frescoed *cherubim* in the ceiling vault. Against the walls: a stone **Wash-Basin** with a carved *Greek Cross* and a 14th century frescoed **Madonna and Child**. The glass cases contain remarkable liturgical objects, such as a fascinating brass **Abyssinian Processional Crucifix** of the 15th century, with a *Madonna and Child* and Coptic inscriptions, probably brought to Florence by the Coptic clergy for the Council of Florence in 1439. Also: a Limoges **Cross** of the 12th century with a *Crowned Christ* on it; various **Crucifixes**, **Paxes** and other nielloed artifacts by Maso Finiguerra (1426-64), some from the Opera del Duomo in Florence; a remarkable **Crucifix**, known as **of San Gaggio**, by Antonio del Pollaiolo and an unknown Florentine goldsmith of the 16th century: the six enamelled silver plaques on this cross were made by Pollaiolo for the monks of San Gaggio between 1476 and 1483, to be mounted on a brass cross (which was probably melted down in 1530, during the Siege of Florence, to mint coinage from) and were re-used by a goldsmith some time around the middle of the 16th century to decorate a gilded copper cross belonging to the same convent. See moreover the fine silver **Censer** and **Incense-Boat**, by an unknown 16th century Florentine silversmith, from the Convent of St. Apollonia in Florence; a magnificent great **Reliquary Crucifix**, decorated with coral (14th century?) and a **Travelling Altarpiece**, by the Workshop of Giotto, early 14th century.

Partial view of the Ivories Room.

# THE IVORIES ROOM

(G – First Floor). From the courtyard, one takes the stairway up to the first floor landing. The room off the landing was restored to its former dimensions in 1857, after being divided up into a series of prison cells for over three hundred years. The room contains wooden statues, panel paintings, etc., as well as the 265 ivory objects from the Carrand collection and other donations, that have been arranged in eight glass cases. The ivories reveal how extensively this material has been used for centuries. Sung by the Odissey and by the Song of Songs, it was considered as precious as gold and was used by Egyptians, Assyrians and Romans, etc. During the Middle Ages, ivory was believed to possess magic properties, capable of neutralising the effects of poison, if the latter were poured into a goblet made of it. In Egypt and Syria, ivory carving flourished as from the 3rd and 4th centuries A.D.; whereas the Alexandrian workshops turned out a host of small, Hellenistic-style reliefs. This tradition was protracted until the 5th-6th centuries, when it developed into Coptic carving. In Syria, the Early Christian ivories interpreted Christian themes in the late-Classical mode. Byzantine sculptors used ivory to illustrate the symbols of the Empire and the Church, until the Iconoclastic Controversy of the 8th and 9th centuries, but after the advent of the Macedonian dynasty (867-1057), Byzantine art blossomed again, producing a host of new master-pieces. In the West, in the time of Charlemagne, wonderful caskets,

combs and fans, like the *Flabellum of Tournus*, shown here, emulating Early Christian and Byzantine products, were produced all over Europe. In the Gothic period, ivory was used for diptychs and triptychs, illustrating religious themes and crowded with figures surmounted by ogee arches, as well as scenes inspired by the Romances, commissioned by the new emerging classes. In the 14th century, the name of the artists started being recorded and although the French School dominated the whole of Europe, the growing interest of Italian artists in ivory was demonstrated by Giovanni Pisano's *Madonna and Child*, with the panel beneath illustrating *Episodes from the Life of Christ* (1299-1300), for the Cathedral of Pisa. At the end of the 14th century, ivory carving declined, notwithstanding the considerable number of goblets, statuettes, reliefs, etc., produced by Flemish and German artists in the 16th and 17th centuries. With the intricate standing goblets and "magic" balls (hollow, concentric open-work spheres), pro-

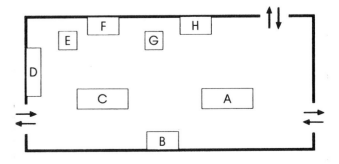

duced by German craftsmen in the 17th century, ivory descended to being the medium of mere skill and dexterity.

Case A – Various 4th-5th century **Pyxides**, **Antefixes** and **Masks**; **Knives** and **Stilettos**, with ivory handles carved with hunting scenes, etc. (Italy 14th-17th centuries); a number of **Statuettes** of the Madonna, e.g.: **Madonna and Child enthroned**, Italy c. 1190, a magnificent instance of Romanesque carving, full of classical majesty; **Madonna and Child**, French, 14th century: the smiling Virgin playing with her Child who holds a little bird in His hand, the bronze base decorated with elaborately enamelled quatrefoils. Various French **Caskets**, e.g.: one of the 12th century, with floral motifs and entwined monsters on the lid, the sides with centaurs and harpies. Lastly: three French 15th century ivory and wood **Jesters' Wands**.

12th century Italian ivory statuette of **Madonna and Child enthroned** and 14th century French ivory statuette of **Madonna and Child.**

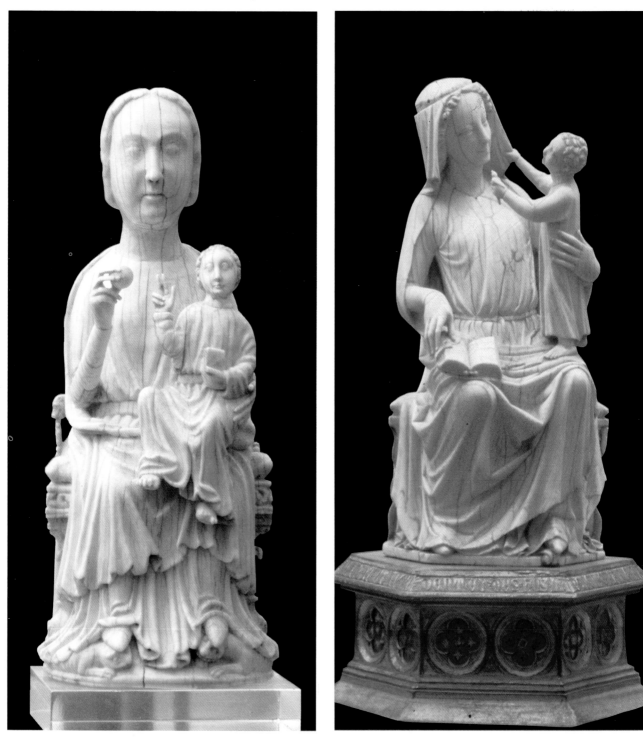

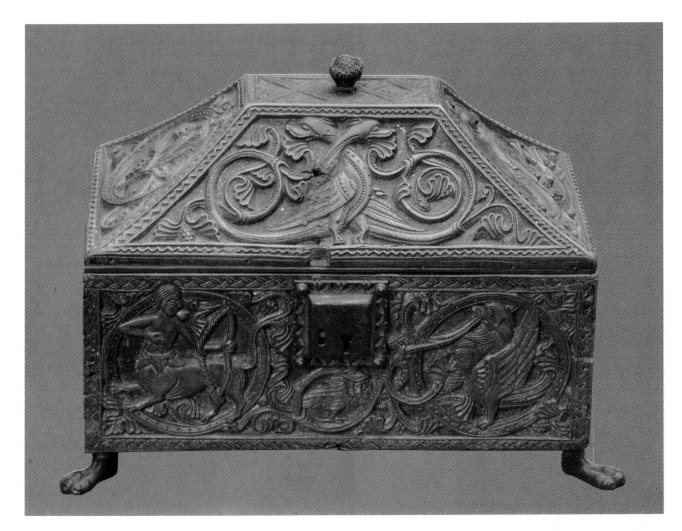

12th century French ivory **Casket;** right: ivory **Pyx** with relief of Orpheus among the animals.

CASE B – Numerous **Statuettes, Reliefs, Plaques,** etc. of more recent periods and of various European provenances, e.g.: 16th century Flemish **Inkstand**, with *Mercury, Polymnia, Venus* and *Adonis; a petrarchan* **Triumph of Love** (relief from a casket), 15th century, Mantua; **Mars**, 16th century, German, with finely chased armour; **Madonna and Child**, a 17th century Spanish plaque, with gold-leaf highlighting.

CASE C – Various exceptional objects of considerable size, such as, for instance: **Large Ivory Casket**, 11th century, Byzantine, decorated with mythological and Christian scenes; **Casket** with barrel-shaped lid, decorated with *Scenes from the Life of the Virgin* (early 15th century, Italian); **Great Chessboard**, with a Back-gammon board on the reverse, the borders decorated with hunting scenes and episodes from the Romances, etc. (Bourgogne c. 1415); **Great Crozier**, carved with an open-work *Virgin and Child enthroned receiving a*

Left: 14th century French **Diptych;** above: great ivory and wooden **Chessboard,** Bourgogne, 15th century; below: 14th century Venetian ivory **Crozier.**

*Bishop,* 14th century Venetian, once the property of Pietro di Montecaveoso, Bishop of Acerenza, from 1334 to 1343; **Flabellum of Tournus,** with ivory handle and parchment fan painted and illuminated with *Scenes from Virgil's Eclogues,* Late Carolingian, Valley of the Loire, mid-11th century.

CASE E – Numerous **Plaques** from Psalter bindings, **Leaves, Panels** and **Diptych Leaves** of various periods and provenances, e.g.: the **Holy Women at the Sepulchre,** fragment from a diptych, School of the Palace of Charlemagne, 8th-9th century; the **Holy Ghost** and **Agnus Dei,** quatrefoil shaped Psalter plaques, Mosan School, c. 1100.

CASE D – A series of **Liturgical Combs,** of various provenances and periods, **Pyxes, Caskets, Plaques** from dagger hilts, etc.; see especially: **Triptych** in bone, hippopotamus tusk and ivory, from the Embriachi Workshop, Northern Italy, 15th century; **Mirror** with magnificently carved frame, Northern Italy, 15th century.

CASE F – Items of various periods and provenances, e.g.: **Chesspieces** and **Draughtsmen,** like: a **Knight,** Northern European chesspiece, 13th century; an **Oliphant of the Sainte Chapelle,** from Paris, Norwegian, 13th century, decorated with etwined monsters devouring each other, etc.

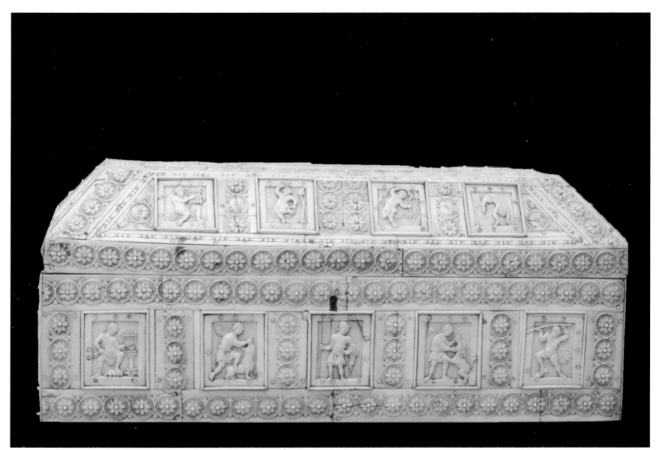

11th century Byzantine ivory **Casket** carved with mythological and Christian figures; below: coffer-shaped ivory **Casket,** carved with scenes from the life of the Virgin, Italian, early 15th century.

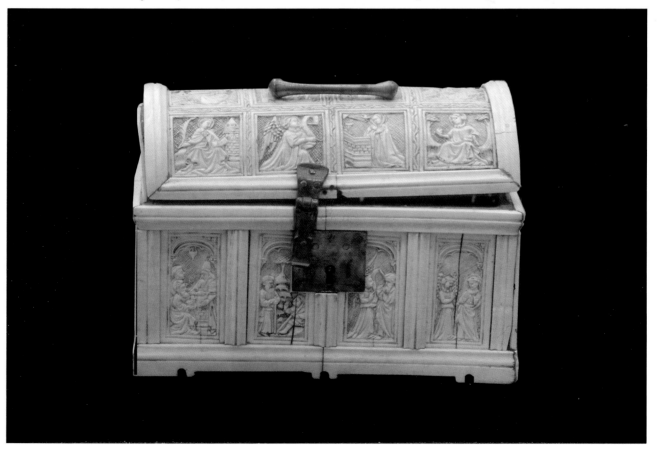

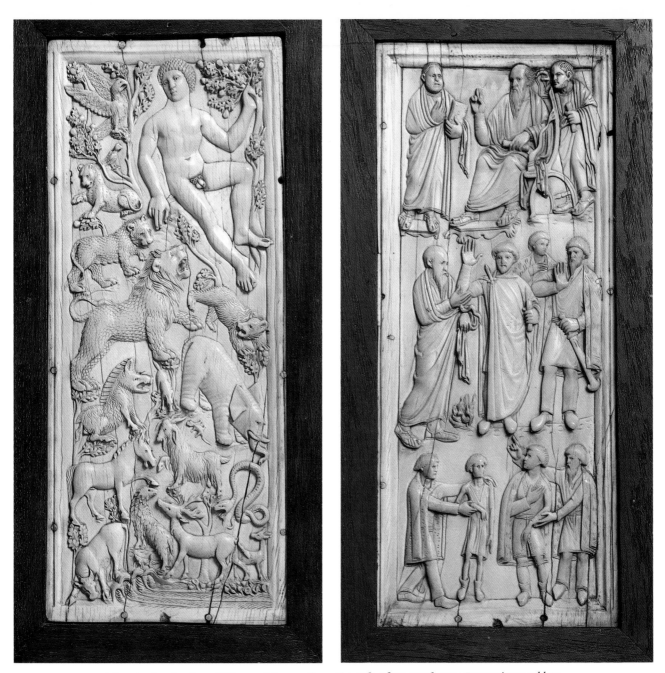

**Adam in the Garden of Eden** and **Scenes from the Life of St. Paul**, Late Roman ivory tablets,
end of the 5th century; opposite: 15th century Umbrian wall statue of the **Madonna of Mercy**.

CASE G – Late Antique ivories, e.g.: the **Empress Ariadne**, a diptych leaf, Byzantine, c. 500 A.D.; **Consul Basilius, a diptych leaf, Late Roman, c. 480 A.D.; Adam in the Garden of Eden** and **Scenes from the Life of St. Paul**, two remarkable diptych leaves, Late Roman, end of the 5th century.

CASE H – French 14th-15th century **Diptychs**, decorated with **Episodes from the Life of Christ** and a series of **Mirror Valves**, decorated with *Episodes from the Romances*, e.g.: **Scenes of the Passion of our Lord**, French ivory diptych, 14th century and **The Castle of Love Besieged**, French, 14th century mirror valve.

On the walls, from left to right, starting from the landing:

**Madonna in adoration**, wooden statue from Umbria or Marche, 14th-15th century.

**Madonna of Mercy**, great wooden wall-statue, Umbria, end of the 15th century. The fundamentally satisfying quality of this Great Mother, spreading her

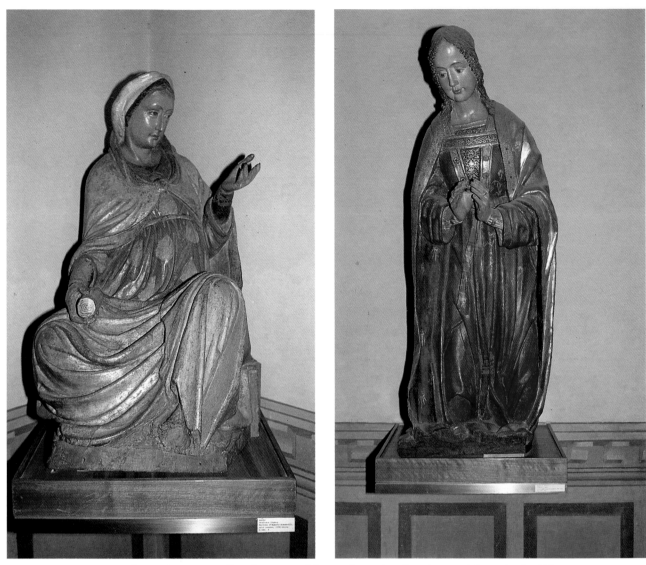

**Nurse,** by *Mariano Romanelli*, 14th century; right: **Madonna in adoration,** Umbria or Marche 14th 15th century.

arms protectively above the thronging figures beneath her cloak is partly due to the "poor" material, painted in bright, elementarily evocative colours.

**Madonna and Child enthroned,** wooden panel with gold-leaf ground, by French Gothic Master.

**Madonna and Child with Angels,** on wooden panel with **Christ Deposed** in the Predella and the crests of the Machiavelli and Strozzi families and portraits of the sponsors.

**Coronation of the Virgin,** by Bernardo Daddi (1290-1348): a pupil of Giotto di Bondone, at times influenced by the sculpture of Andrea Pisano and by French ivory carving.

**Christ Blessing,** 11th century Bizantine mosaic.

**St. Anne, the Virgin and Child,** 13th century wooden polychrome group.

**Nurse,** painted wooden statue (1390), by Mariano Romanelli.
Probably part of a group representing the *Nativity of the Virgin,* it seems to anticipate many aspects of 15th century sculpture.

**Judgement of Paris,** childbirth stool, Florentine, 1430.

**St. Barbara,** polychrome wooden statue, Pisan School, 14th century.

**Bust of St. Peter,** mosaic panel, attributed to Domenico or Davide Ghirlandaio, it probably belonged to the Magnificent Lorenzo de' Medici; a rare example of 15th-16th century mosaic art.

**Madonna and Child,** polychrome wooden statue, of Umbrian School.

**Holy Bishop,** polychrome wooden statue of 13th century Sienese school.

# THE GIOVANNI DELLA ROBBIA ROOM

(A – Second Floor) Giovanni della Robbia (1469-1529) belonged to the famous family of sculptors and ceramists. He worked with his father Andrea for a number of years. His lively style was more highly coloured and rustic, less controlled and intent on obtaining the balanced harmony, achieved by his great-uncle Luca and by his father. With the object of transforming sculpture into painting in relief, he added tint to tint, often in strident contrast with each other, wherefore his works differ remarkably from the peaceful, balanced polychrome harmonies of his predecessors. His production was prodigious. His great compositions, often populated by stalwart, static figures combine a series of heterogeneous elements without achieving particularly admirable effects.

The room also contains four recently arranged glass cases (three in the middle of the room and one against the wall), in which one can admire numerous medals, plaques, small frames, etc. of North European, Paduan, Florentine, German, French, Spanish, etc. provenance of the 15th-17th centuries. See particularly the bronze-gilt series of **Roman Emperors** (Italy, 16th century).

**Nativity**, by Marco (Fra Mattia) della Robbia (?), a round-arched glazed polychrome terracotta relief, framed by a garland of fruit and flowers, supported by a bracket with an *Angel-head* in the centre.

**Annunciation**, by Giovanni della Robbia, a fine lunette in polychrome terracotta, from the Convent of the Santissima Annunziata dei Servi, in Florence.

**Adoration of the Child**, by the Della Robbia Workshop, a great glazed polychrome terracotta roundel, surrounded by a garland of flowers and fruit.

**Madonna and Child**, by Giovanni della Robbia, a round-arched polychrome terracotta relief, surrounded by a garland of flowers and fruit, with a family crest in the bracket.

**Ciborium**, with *Cherubs* and *Angels* (1480-90), by Benedetto Buglioni (Florence 1461-1521), from a composition, by Antonio Rossellino; once in Santa Lucia in Camporeggi.

**The Maries at the Sepulchre** (1521), a polychrome terracotta lunette, by Giovanni della Robbia, from the Convent of the Santissima Annunziata dei Servi.

**Madonna and Child with little St. John**, polychrome terracotta roundel, surrounded by a garland of flowers and fruit, from the Convent of the Santissima Annunziata alle Murate.

**Madonna and Child** (1490-1500), round-arched panel in polychrome glazed terracotta, from Benedetto Buglioni's Workshop.

**Bacchus** (c. 1520), by Giovanni della Robbia, a polychrome glazed terracotta bust, from the Deposits of Palazzo della Signoria.

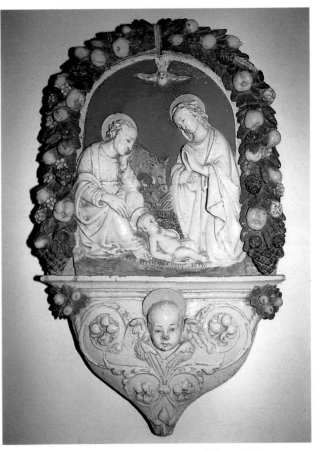

**Nativity**, by *Marco (Fra Mattia) della Robbia* (**?**), below: **Madonna and Child**, by *Giovanni della Robbia*.

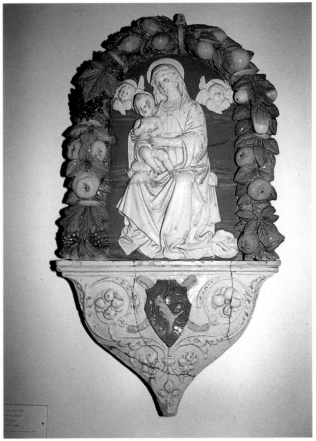

Partial view of the Giovanni della Robbia Room; below: **Bacchus,** by *Giovanni della Robbia*.

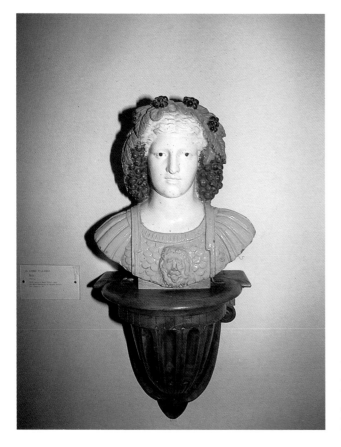

**St. Ursula**, from Giovanni della Robbia's Workshop.

**St. Augustine** and **Noli Me Tangere** (1500-05), by Giovan Francesco Rustici (Florence 1474-Tours 1554) and Giovanni della Robbia, white and yellow glazed terracotta lunette and altarpiece, once in the Convent of Santa Lucia a Camporeggi.

**Bust of a Youth**, in natural terracotta, Florentine, 15th century (?).

**Little St. John in the Desert**, by the Master of the Little St. John, a natural terracotta figure seated in a rocky landscape.

**Prophet**, a Sansovino-style lunette in glazed terracotta, by the Della Robbia Workshop.

**Resurrection of Christ** (1510), by the Della Robbia Workshop, a polychrome glazed terracotta shrine with bracket, from the Convent of San Bartolommeo a Monteoliveto.

**St. Martha and two Angels** (c. 1515-20), by Andrea della Robbia's Workshop, from the Church of Santa Marta.

**Madonna and Child with little St. John** (c. 1470) a partially glazed and coloured terracotta roundel, based on a composition by Verrocchio, surrounded by a garland of flowers and fruit, by Giovanni della Robbia.

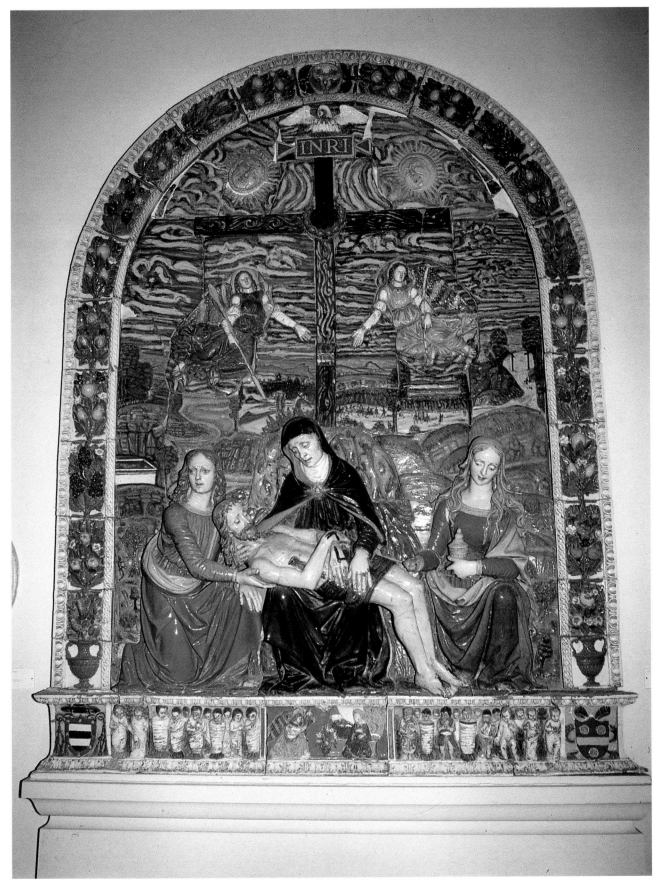

**Deposition,** by *Giovanni della Robbia*.

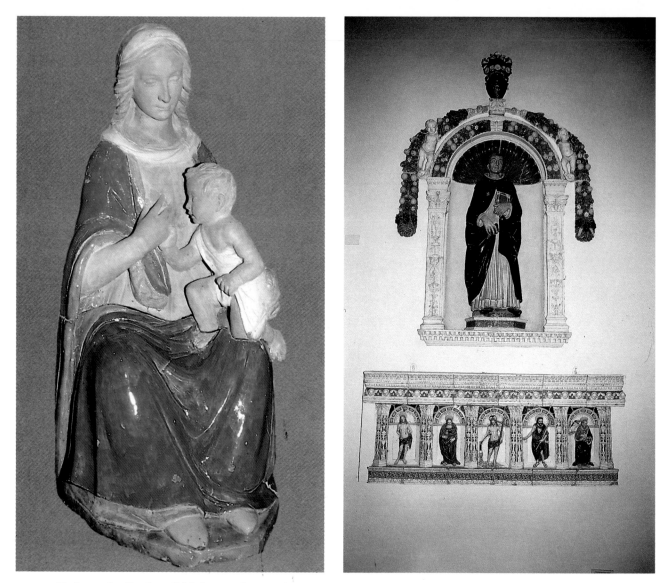

**Madonna feeding her Child,** by *Benedetto Buglioni*; **St. Dominic** and predella with **Jesus, the Magdalen, St. John the Baptist, St. Sebastian and St. Matthew,** from the *Della Robbia Workshop*.

**Angels in Glory**, a fragment from Giovanni della Robbia's Workshop (?).

**Ascension of Christ**, by Benedetto Buglioni's Workshop, a rectangular panel in glazed terracotta with a frame decorated with white ovolo moulding.

**Madonna feeding Her Child**, a partially coloured and glazed terracotta statue, by Benedetto Buglioni.

**Baby Jesus appears to little St. John** (1510), a little glazed terracotta group, by Benedetto Buglioni.

**Noli Me Tangere**, great glazed terracotta altarpiece, with **Predella**, illustrating the *Stigmata of St. Francis*, by Benedetto Buglioni and Santi Viviani, known as Buglioni.

**Frieze with Gorgon and Trophies**, glazed terracotta relief by the della Robbia Workshop, based on a motif by Benedetto da Rovezzano.

**Nativity** (1521), great glazed terracotta altarpiece, sur-rounded by *Angels*, a roundel in the arched top of the panel with the *Creator Blessing* and the *Holy Ghost*, by Giovanni della Robbia.

**Noli Me Tangere** (1525-30), a great rectangular glazed polychrome terracotta altarpiece, by Santi Viviani, known as Buglioni.

**St. Joseph** (1530-40), glazed terracotta oval by Santi Viviani, known as Buglioni.

**Christ Deposed** or **Man of Sorrows** (1514-15), by Giovanni della Robbia; beneath: **Predella** with *An-nunciation* and *Babes in swaddling clothes*.

**St. Augustine** (1530-40), a glazed terracotta oval, by Santi Viviani, known as Buglioni.

**St. Dominic**, a polychrome terracotta statue in a niche, surrounded by a garland of fruit and flowers; beneath: a **Predella** with *St. Sebastian*, the *Magdalen*, *Jesus*, *St. John the Baptist* and *St. Matthew*.

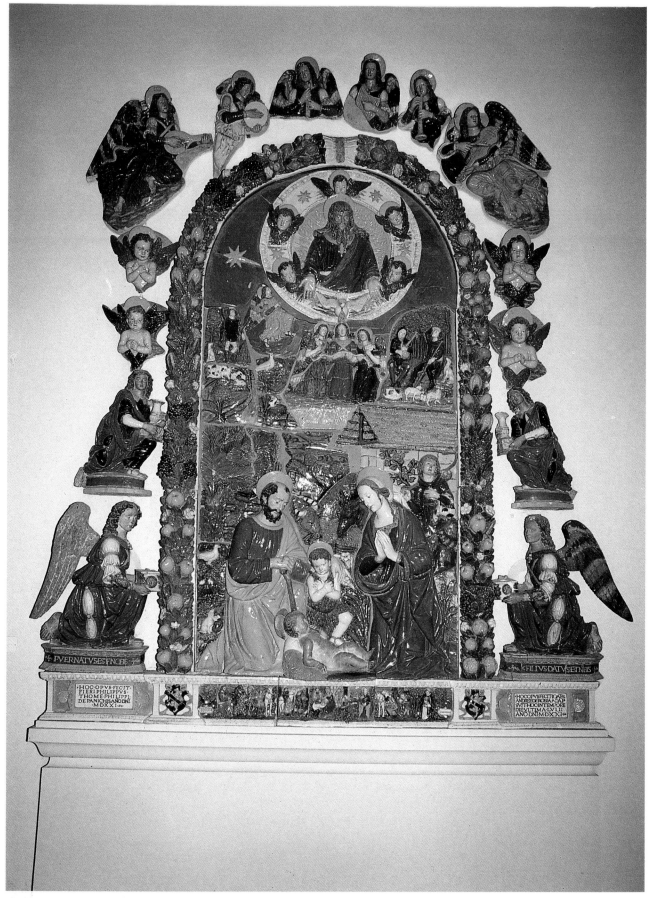

**Nativity,** coloured and glazed terracotta altarpiece, by *Giovanni della Robbia*.

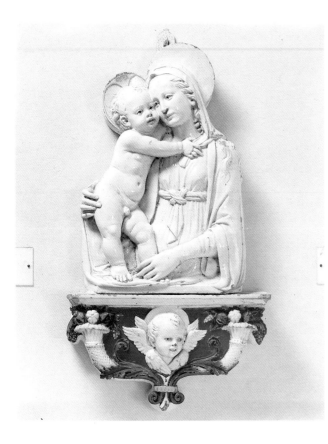

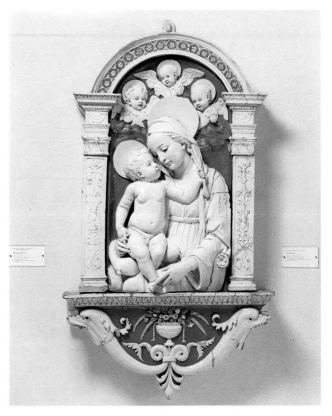

Left: **Madonna and Child;** above: **Madonna of the Cushion;** below: **Madonna of the Lilies,** all from *Andrea della Robbia's Workshop.*

# THE ANDREA DELLA ROBBIA ROOM

(B – Second Floor). Andrea (1435-1525) worked with his uncle Luca della Robbia and inherited his prosperous workshop after Luca's death. His output was prodigious. Much influenced by Verrocchio, he differed from his uncle Luca's serene classicism, in his search after pictorial effects, achieved by means of a more lively palette. Towards the end of the century, the enormous number of commissions forced Andrea to rely increasingly on his numerous assistants, who produced dozens of replicas of the most successful works, sometimes using rather hasty, or careless methods or confining their ambitions to the production of merely decorative, conventional pieces.

**Madonna and Child**, (c. 1490), by Andrea della Robbia's workshop, the figure in relief on a bracket supported by *horns of plenty* and *angel-head.*

**Madonna of the Cushion** (c. 1495), by Andrea della Robbia (Giovanni?); a fine glazed terracotta relief upon a bracket with *dolphins* and central sheaf of *flowers,* from the Badia Fiorentina.

**Annunciation** (c. 1505), by Andrea della Robbia's workshop.

**Ciborium**, by Andrea della Robbia's Workshop, with the *Eucharist* above and bracket supported by *horns of plenty* and *angel-head.*

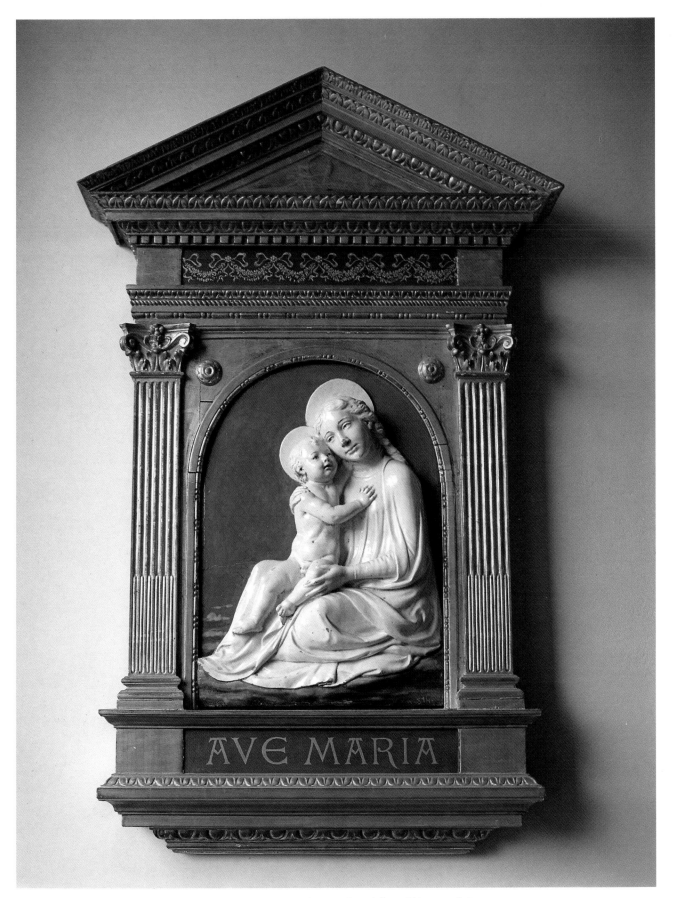

**Madonna of Humility,** from *Andrea della Robbia's Workshop*.

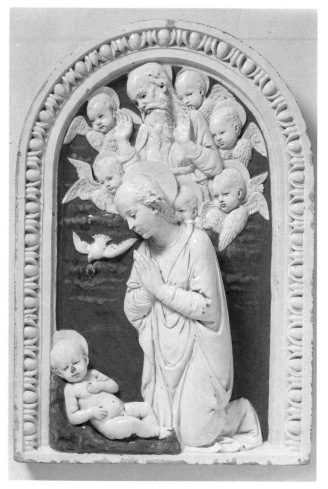

Right: **Adoraton of the Child**, from *Andrea della Robbia's Workshop*; above: Portrait of a **Young Girl**, by *Andrea della Robbia*.

**Adoration of the Child**, by Andrea della Robbia's Workshop, the *Creator*, *Cherubim* and the *Holy Ghost* in the background within a round-arched ovolo-moulded frame.

**Madonna of the Lilies** (1490-95), by Andrea della Robbia's Workshop; an unframed round-arched glazed terracotta panel with bracket supported by *horns of plenty*.

**Madonna and Child**, by Andrea della Robbia's Workshop; a white and blue glazed terracotta roundel surrounded by *Cherubim* and *ovolo* moulding.

**Flagellation** and **Ascension**, two rectangular panels, probably from an altar predella, by Andrea della Robbia.

**Carved wooden chest**, Florentine, 16th century.

**Madonna of the Lilies** (c. 1490), by Andrea della Robbia's workshop; a round-arched glazed terracotta panel surrounded by a garland of fruit and flowers, supported on a bracket on volutes with armorial crest.

**Washbasin**, in grey sand-stone, with *Medusa head* in relief and crest of the *Acciaioli-Federighi*, as well as crests of the *Medici* and of the *Lion Rampant* of the *Florentine People*; dated 1499; once in the Acciaioli mansion in Borgo Santi Apostoli.

**Madonna of Humility** (c. 1465), by Andrea della Robbia's Workshop; round-arched glazed white and blue terracotta panel, with gilded wooden frame with tympanum.

**Madonna of the Architects** (1475), by Andrea della Robbia; a fine, glazed terracotta shrine, surrounded by *rose-sprays* and *cherub-heads*, cast for the Guild of the Stone-masons and Wood-carvers (see the *tools* beneath the figure of the Mother). The sand-stone bracket, with the *Silk-Guild's Crest*, is attributed to Francesco di Simone Ferrucci.

**Carved wooden chest**, Florentine, 16th century.

**Roundel with Portrait of a Young Girl** (1465-70), by Andrea della Robbia; glazed terracotta head almost completely detached from its blue glazed background; once in the deposits of Palazzo della Signoria.

**Idealized Portrait Bust of a Boy**, by Andrea della Robbia (1475-80); probably a portrait of Piero di Lorenzo de' Medici.

**The Dove of the Holy Ghost** (c. 1465-70), by Andrea della Robbia; fragment from a relief.

**Madonna and Child**, by Andrea della Robbia's Workshop; a small glazed terracotta roundel, surrounded by a garland of flowers and fruit.

# THE BRONZE STATUETTES ROOM

(D – Second Floor). Since 1975 it has contained a large collection of bronze statuettes, formerly in the Uffizi, Palazzo della Signoria and in the Carrand collections, etc.

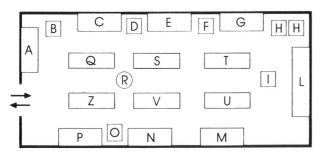

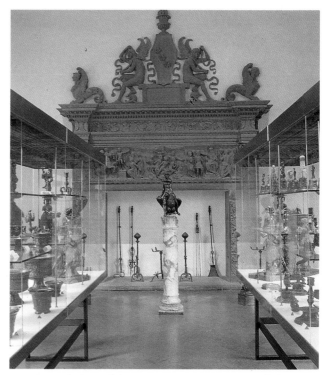

**Partial view of the Bronze Statuettes Room;** below: **Ganimede,** attributed to *Benvenuto Cellini*.

CASE A – Various statuettes, reproducing in reduced size masterpieces of antiquity, by 16th century Italian artists, such as: **Laocoön**, **Narcissus**, **Antinous**, **Cybele**, **Hercules**, etc. See moreover: the dynamically realistic **Man of Fear**, a figurine attributed to Donatello; the gilt-bronze **Athlete**; **Marcus Aurelius**, a copy of the famous statue once on the Capitoline Hill, with an ornamental base, by Ludovico del Duca (1551-1601).

CASE B – A copy of the **Farnese Bull**, attributed to Piero da Barga (c. 1580).

CASE C – Entirely devoted to statuettes by Piero da Barga, reproducing antique and 16th century masterpieces, e.g.: **Flora**, **Laocoön**, **Hercules and Telephus**, **Rape of Persephone**.

CASE D – **The Killing of Argus**, by G.B. Foggini (1652-1725).

CASE E – Various statuettes by Andrea Briosco, known as il Riccio (1470-1532), as well as a series of unusually shaped **oil-lamps**, e.g.: **Tryton and Nereid**; **Jupiter and the Goat Amalthea**; **Satyr in chains**, etc. See also a number of 15th and 16th century Paduan and Venetian statuettes, such as the **Rape of Europa** and a variety of **animals**.

CASE F – **Boar with four figures** (1630), after the original marble statue in the Uffizi, with a wooden base inlaid with semi-precious stones, by G. Fr. Susini (Florence ?-1646).

CASE G – Various 16th century Italian statuettes of animals, some mounted on wooden or marble bases, e.g.: **Viper and Lizards**; **Hedgehog**, **Horses**; **Flowers**; **Crab**; **Toad**, etc.

CASE H – **The Flayed Man**, an interesting anatomical study in bronze, of a human male figure, with the wax model beside it, on a wooden base, by Ludovico Cardi, known as Cigoli (Florence 1559 - Rome 1613).

I – **Ganimede**, by Benvenuto Cellini. The attribution of this piece to Cellini is still questioned: Venturi expressed his doubts and Camesasca (1955) suggested that Tribolo might have cast it. The lively expression on the boy's face and the harmonious composition are admirable.

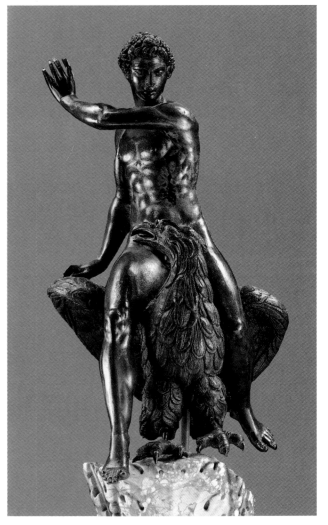

L – **Fireplace**, by Benedetto da Rovezzano (1474-1552); a splendid piece in grey sand-stone, carved in 1518, with the mantlepiece carved in relief with the stories of *Croesus* and *Cyrus*, for the Borgherini Mansion; four great bronze **Fire-dogs**, by Niccolò di Roccatagliata (1595-1636); **Tongs**, **Pokers**, **Shovels**, etc.

CASE M – Various 16th century Italian busts in the antique style, such as a splendid **Head of Antinous**; four **Birds**, by Giambologna and a **Bust of Francesco Maria II della Rovere**, by Giovanni Bandini, known as dell'Opera (Florence 1540-99).

CASE N – Various statuettes by Baccio Bandinelli, including the **Busts of Cosimo I** and **Eleonora of Toledo**; **Leda**, **Cleopatra**, **Venus**, **Hercules**, etc. Moreover: a **Bacchus with a Satyr at his feet**, Florentine School, 16th century and an **Inkwell with Pan playing the Pan-pipes**, by Niccolò Pericoli, known as Tribolo (1500-58).

O – **St. Louis of France** (1723), by G. Piamontini.

CASE P – A series of beautiful pieces, by Giambologna, e.g.: **Architecture**; **Christ at the Column**; **Madonna and Child**; **Hercules and the Caledonian Boar**; etc. See also a bronze **Oval Panel** with a **Deer Hound** (Saluki?), by Benvenuto Cellini, mentioned in the artist's writings, as a trial piece for the *Perseus* casting.

CASE Q – Various statuettes by Giambologna, such as the fine series of the **Labours of Hercules**; see also a

**Fireplace,** by *Benedetto da Rovezzano*; below: bronze **Firedog,** by *Niccolò di Roccatagliata* and Italian 16th century bust of **Julius Caesar.**

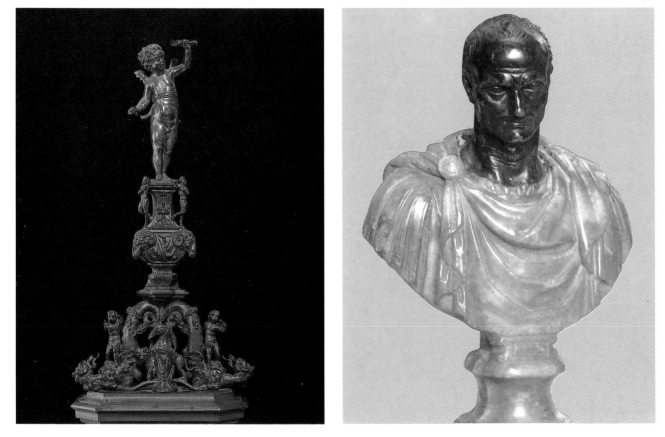

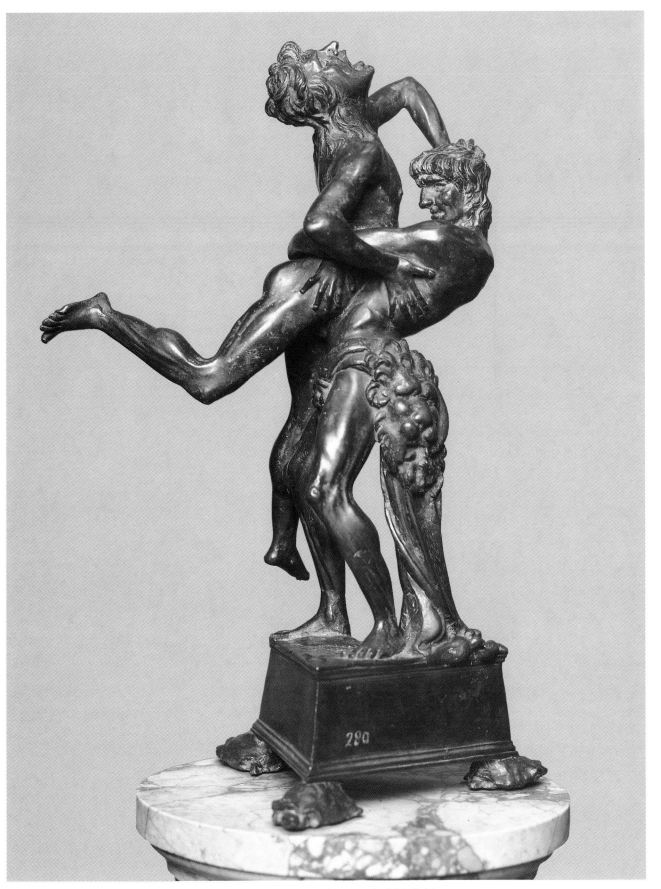

**Hercules and Antaeus,** by *Antonio del Pollaiolo*.

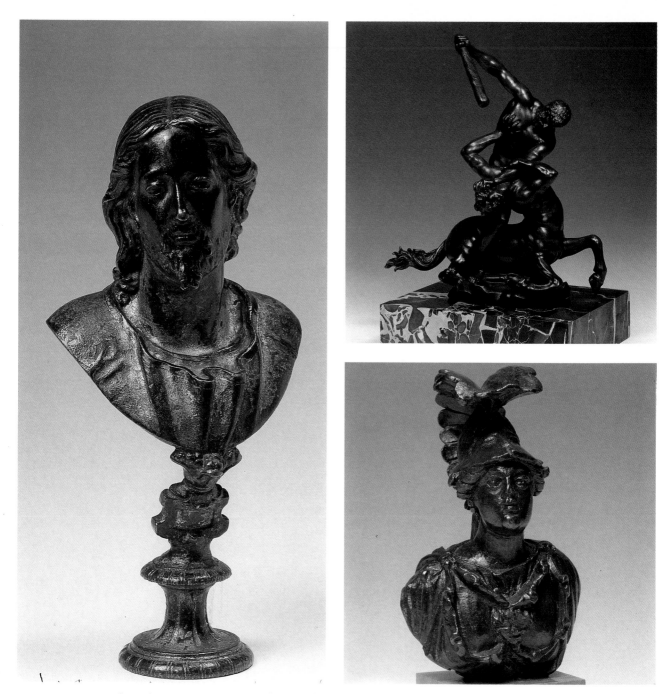

Left: 16th century Italian bust of the **Redeemer**; above: **Hercules and the Centaur,** from *Giambologna's Workshop*; right: 16th century Italian bust of **Athena-Minerva**.

fine **Aquamanile**, surmounted by the figures of the *Dwarf Morgante* and a *Dragon*, by Giambologna and Vincenzo della Nera.

CASE R – **Hercules and Antaeus**, by Antonio del Pollaiolo (Florence c. 1431 - Rome 1498); this famous work, commissioned by Giuliano de' Medici, reveals the artist's interest in human anatomy. The figures confront each other in tautly defined emotional and dynamic tension. Pollaiolo's contacts with Andrea del Castagno are here most apparent.

CASE S – Various statuettes by Andrea Briosco, known

as il Riccio (1470-1532) and his Workshop, such as, for instance, an **Inkwell** upon a triangular base with a *Faun*; see also **Neptune** (c. 1500), by Severo da Ravenna; a bronze **Bust of Julius Caesar**, the drapery in calcedony, Italian, 16th century.

CASE T – An interesting 16th century collection of Italian **Mortars** and **Cups**; two **Branched Candlesticks**, with **Twin-tailed Mermaids**, by Riccio's Workshop; see also **War-twin or Dioscurus** and a splendid **Antinous**, attributed to William of Flanders (Willem Danielsz van Tetrode), second half of the 16th century.

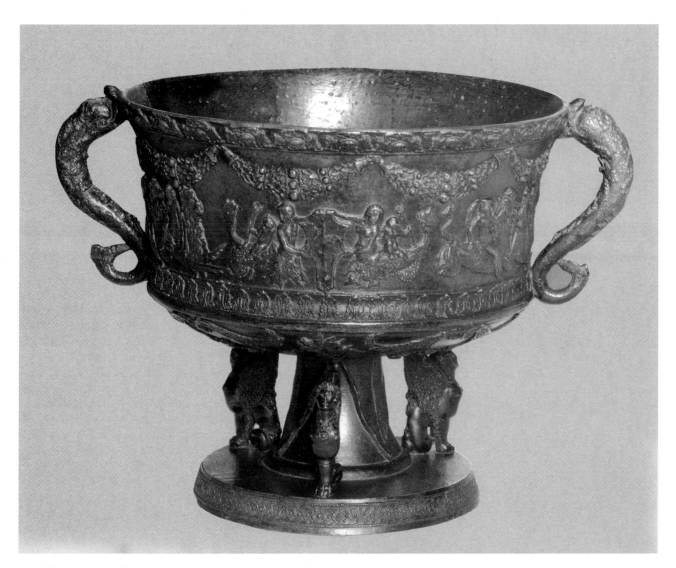

16th century Italian bronze **Cup**; right: **the Dwarf Morgante**, by *Giambologna* and *Vincenzo della Nera*.

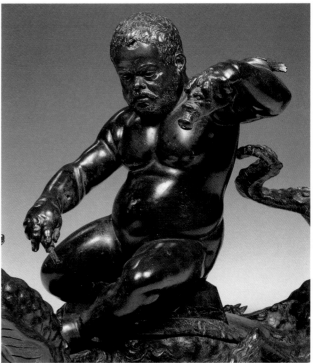

CASE U – Another splendid **War-twin** or **Dioscurus**, by William of Flanders and an interesting collection of bronze **Table-bells** of various periods and sizes; a splendid **Satyr**, by Massimiliano Soldani (1658-1740); various 16th century Venetian **Candlesticks** and a fine Northern Italian, 16th century **Hanging Lamp**.

CASE V – Numerous 16th and 17th century statuettes, such as **Venus and Adonis, Mars**, etc.; **Bacchus**, by Jacopo Benzi (1656-1750); a copy of the **Dying Gaul**, by G. Francesco Susini as well as a number of **Putti, Children** and a grotesque **Pair of Dwarfs** (17th century, Florentine).

CASE Z – Various statuettes after Giambologna, such as **Mercury**; the **Rape of the Sabines**; A **Bull and a Horse attacked by two Lions**, etc.; see also: **Mercury**, by William of Flanders (1560).

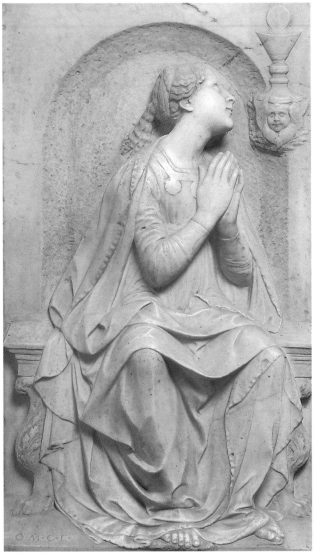

Faith, by *Matteo Civitali*; below: **partial view of the Verrocchio Room.**

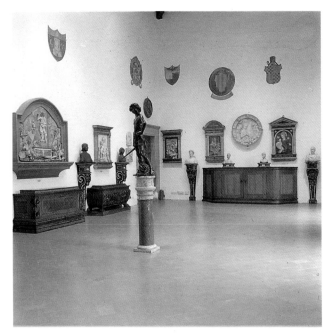

# THE VERROCCHIO AND LATE 15TH CENTURY SCULPTURE ROOM

(C – Second Floor). Completely restored during the last century, it has a raftered ceiling and a great central lantern. The wall decorations are by Gaetano Bianchi. The Tuscan sculpture, formerly in the Uffizi Gallery, was arranged in this room in 1873 and more recent acquisitions have been added over the years.

**Arms of the Commune of Florence** (above the entrance), a 15th century marble relief.

**Portrait of an Unknown Lady**, by Matteo Civitali (Lucca 1436-1501). Both as a sculptor and as an architect, Matteo was influenced in his youth by Antonio Rossellino and Benedetto da Maiano and can be considered one of Donatello's many disciples. Possessing a profoundly spiritual outlook, he produced delicate little figures, like this bust. His most renowned architectural project was the measured, harmonious *Shrine of the Volto Santo*, for the Lucca Cathedral (1482-84).

**Battista Sforza, Duchess of Urbino**, a marble bust, by Francesco Laurana (Vrana, Zara c. 1430 - Avignon? 1502). One first encounters this sculptor, architect and medallist, of almost unknown origins, in 1458, in Naples, where he worked on Alphonse of Aragon's triumphal arch (probably in charge of the whole project). His figures often appear abstracted and unaware of their surroundings. The glacial immobility of the Duchess' face is probably due to the fact that her features were drawn from a death-mask. The bust, (carved in Urbino, in 1472, after the death of this twenty-eight year-old daughter of Alessandro Sforza) came to Florence, together with the rest of Vittoria della Rovere's inheritance (like the *Portrait of the Duchess*, greatly resembling this bust, by Piero della Francesca, in the Uffizi), towards the middle of the 17th century.

**Faith**, marble relief of a female figure seated in a niche, worshipping the symbols of the *Eucharist*, by Matteo Civitali. The graceful precision of the drapery remind one of Rossellino's and Verrocchio's influence on the artist.

**Madonna and Child**, 15th century marble relief, by Verrocchio's Workshop.

**Death of Francesca Pitti Tornabuoni**, by Andrea di Cione, known as Verrocchio (Florence 1435 - Venice 1488). As a sculptor, Verrocchio was a follower of Donatello, as a painter, he admired Pesellino and Alesso Baldovinetti. He soon revealed his own distinctive personality, possessing great technical skill both as a draftsman and as a sculptor. He greatly preferred sculpture to painting and most of his works are single figures of great intellectual impact and meticulously defined grace that remind one of his early training as a goldsmith. In 1405, he was already running his own workshop, where he was assisted by a large number of apprentices, one of

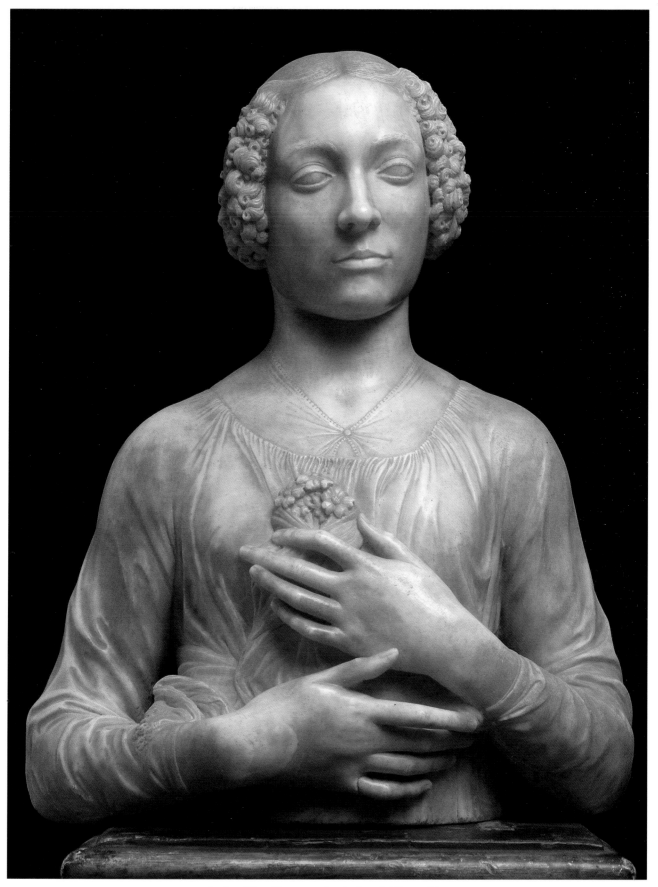

**Lady with a Nosegay,** by *Andrea del Verrocchio.*

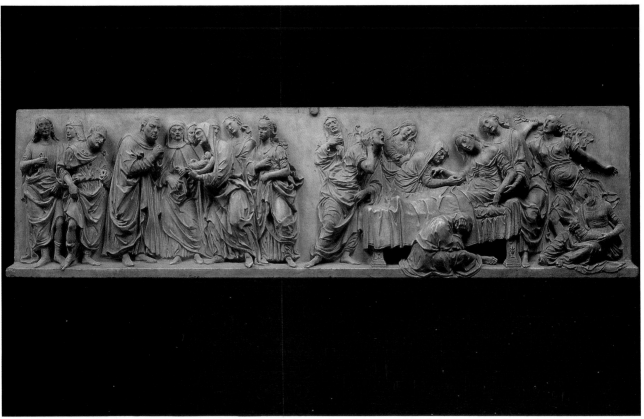

**Death of Francesca Pitti Tornabuoni,** by *Andrea del Verrocchio*; below: Portrait bust of an **Unknown Man,** by *Antonio del Pollaiolo*.

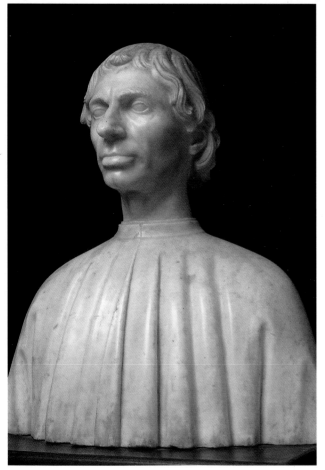

them being Leonardo da Vinci. Verrocchio was protected by the Magnificent Lorenzo de' Medici and carried out a large number of projects for him, such as busts, statuettes and breast-plates, as well as the *Sepulchre for Giovanni and Piero de' Medici*, in the Basilica of San Lorenzo, in Florence. The relief in this room was to have decorated the *Sepulchre*, commissioned by Giovanni Tornabuoni (Lorenzo de' Medici's agent in Rome) for his wife — who died in childbirth in 1477 and was buried in Santa Maria sopra Minerva, in Rome. The sepulchre was never completed. The inventive skill of the composition shows how far Verrocchio had progressed in his search after novel ways of employing Donatello's low-relief (schiacciato) technique.

**Carved wooden chest**, Florentine, 16th century.

**Portrait of an Unknown Man**, marble bust, by Antonio Benci, known as Pollaiolo (Florence c. 1432 - Rome 1498). Apprenticed to Bartoluccio (Lorenzo Ghiberti's step-father), with whom Antonio worked on the *Doors* of the Florentine Baptistery, he was later much influenced by Andrea del Castagno and Donatello, from whom he absorbed his vigorous draftsmanship, revealing an anatomical knowledge which aroused both Mantegna's and Dürer's admiration. The solid modelling of this bust enhances the strongly individualistic features of the face.

**Madonna and Child**, natural terracotta relief, partly

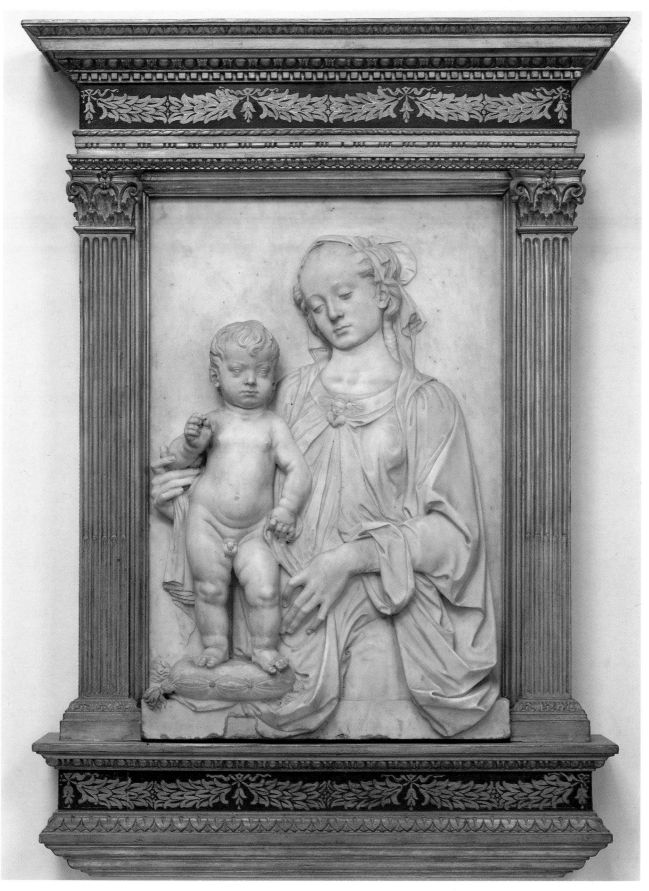

**Madonna and Child,** marble relief, by *Andrea del Verrocchio*.

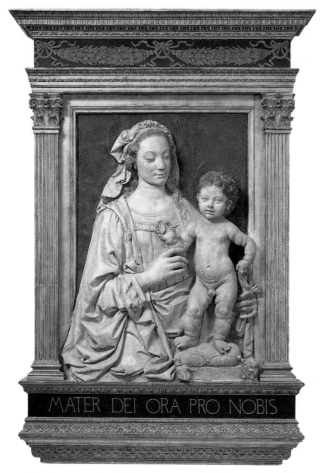

**Madonna and Child,** terracotta relief, by *Andrea del Verrocchio*; below; **Battista Sforza, Duchess of Urbino,** marble bust, by *Francesco Laurana*.

coloured and gilded, by Andrea di Cione, known as Verrocchio; from the Hospital of Santa Maria Nuova, in Florence.

**Lady with a nosegay,** marble bust of a lady holding a nosegay to her breast, by Andrea di Cione, known as Verrocchio. Not all critics agree in attributing the celebrated grace and vitality of this masterpiece to Verrocchio, some affirming that the hands and flowers could have been carved by his youthful apprentice, Leonardo da Vinci. In view of the friendship that bound Verrocchio to Lorenzo de' Medici, others have moreover attempted to identify the woman as Lucrezia Donati, Lorenzo's beloved; others still see a resemblance of the lady's features with those of Ginevra Benci (also portrayed by Leonardo da Vinci).

**The Resurrection,** by Andrea di Cione, known as Verrocchio; a polychrome terracotta relief, once in the Chapel of the Medici Villa of Careggi, where the artist also created a garden fountain, for which he cast his delightful and world-renowned bronze *Cupid clasping a Dolphin,* now in Palazzo della Signoria.

**Carved wooden chest,** Florentine, 15th century.

**Piero di Lorenzo de'Medici,** a terracotta bust, by Andrea di Cione, known as Verrocchio. The eldest son of the Magnificent Lorenzo and of the Roman lady, Clarice Orsini, he was born in 1471. His arrogant, fatuous personality was his undoing, when he inherited his father's political and social position. He weakly submitted to Charles VIII of France's demands and his ineptitude was such that the infuriated Florentines expelled both Piero and the whole Medici family from Florence, on the 9th November 1494, pillaging the Medici Mansion on Via Larga (now Cavour). Piero took refuge in Bologna and Venice, joining forces with the French king, in the hope of being able to re-enter Florence under his protection, whilst the king was engaged in trying to conquer Naples. Piero was drowned, in a boat full of soldiers and cannons, that capsized while crossing the Garigliano river, in 1503.

**Madonna and Child,** a marble panel in relief, by Andrea di Cione, known as Verrocchio and Workshop. The frame is decorated with bay-leaf festoons, the bay or laurel-tree being much loved by Verrocchio's patrons: the Medici.

**Carved wooden chest,** Florentine, 16th century.

**Bust of a Young Warrior,** in blackened terracotta, by Antonio di Benci, known as Pollaiolo; believed to be a portrait of young Giuliano de'Medici (murdered in the Cathedral in 1478, aged twenty-five, during the Pazzi Plot), to celebrate the famous tourney staged in Piazza Santa Croce, in 1469, in honour of his brother, Lorenzo. Machiavelli said of him "there was in him such liberality and humanity as could be desired in no other man of such destiny". The breast-plate is decorated with *Hercules fighting two serpents* and *Hercules fighting a bird from the Stymphalian Marshes.*

**Resurrection,** terracotta relief, by *Andrea del Verrocchio*; below: 16th century **carved Chest**.

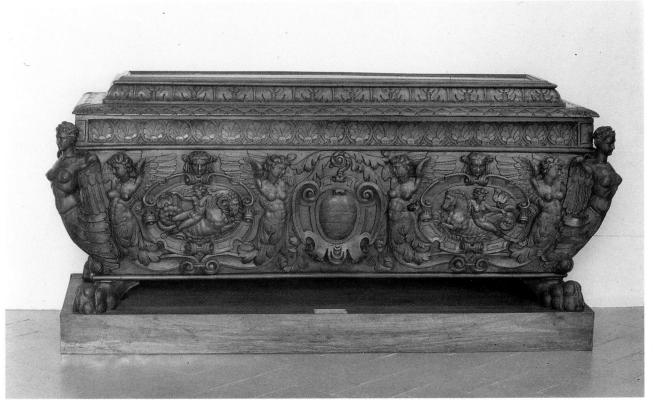

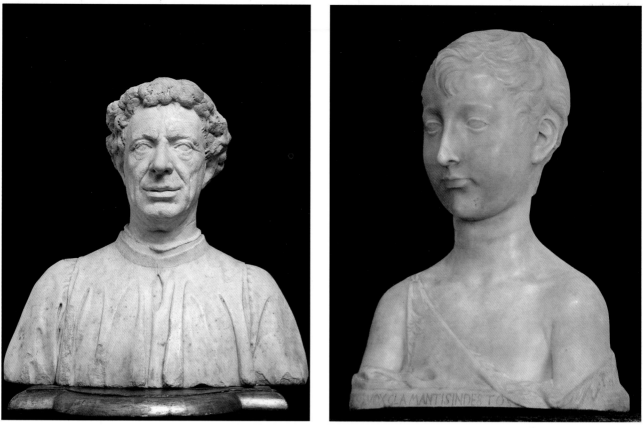

**Matteo Palmieri** and **St. John the Baptist as a Boy,** marble busts, both by *Antonio Rossellino*;
below: **Madonna and Child,** terracotta relief, by *Tommaso Fiamberti.*

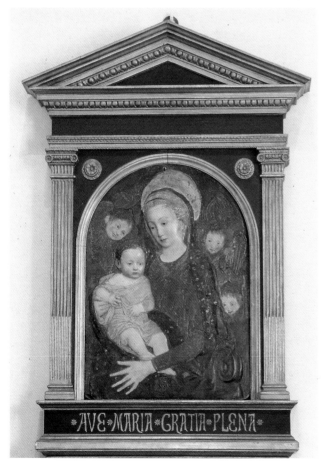

**Madonna and Child,** by Francesco di Simone (1437-c. 1492). Assistant to Ghiberti, Francesco was also influenced by Desiderio da Settignano and Verrocchio, exhibiting an exuberant, fanciful decorative sense and an eclectic grace.

**Madonna and Child,** marble relief by Antonio Rossellino (Settignano 1427 - Florence 1478/81?). Antonio grew-up in the workshop of his brother, Bernardo (who designed Pienza) and made his name with the *Sepulchre for the Cardinal of Portugal,* in San Miniato al Monte, in Florence. He moved among the humanist scholars of his time and his work is a harmonious blend of sculpture, architecture and draftsmanship. The figures in this relief are highlighted in gold leaf — his Baby wrapped in swaddling-clothes, like the Della Robbia babies at the Hospital of the Innocents.

**Madonna and Child,** a small coloured terracotta roundel in relief, by Benedetto da Maiano (Maiano 1442 - Florence 1497). As a follower of Antonio Rossellino, Benedetto worked both as a sculptor (often together with his brother, Giuliano) and as an architect, combining his miniature-painter-like sense of physionomy with a profound sense of harmony and proportion.

**Madonna and Child with Angels,** a rectangular polychrome terracotta relief, by Antonio Rossellino.

**Matteo Palmieri,** a marble portrait bust (1468), by Antonio Rossellino. The lively realism and psycholog-

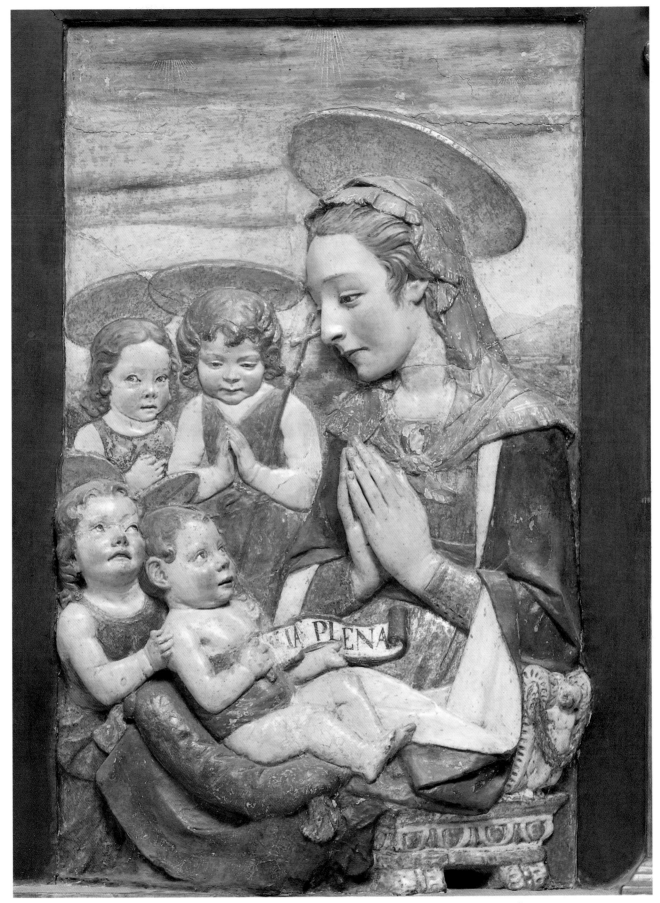

**Madonna and Child with angels,** polychrome terracotta relief, by *Antonio Rossellino*.

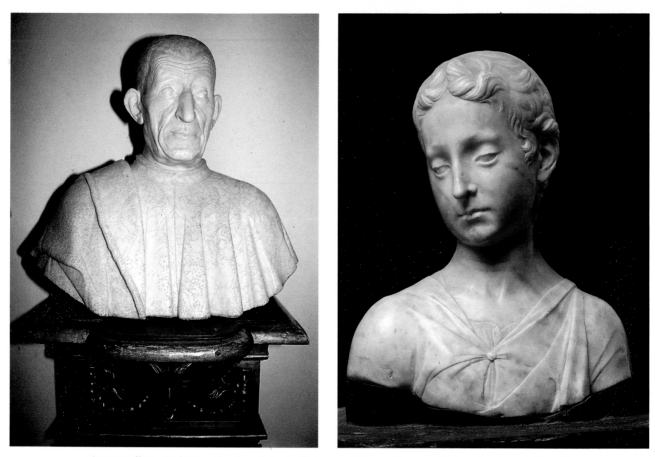

**Pietro Mellini,** marble bust by *Benedetto da Maiano* and **Young Boy,** marble bust by *Antonio Rossellino*.

ical insight of this famous portrait are a tribute to the likeable, generous features of the author of the Dialogue "Della Vita Civile", born in 1406. As a young man, Palmieri not only moved, like Rossellino, among the humanist scholarly circles of Florence, but also followed his father's profession as a pharmacist (the bust, used to be above the door of his house and shop in the parish of San Pier Maggiore, in today's Via Pietrapiana, and remained there until 1701). As from 1432, Palmieri was appointed Florentine Deputy (Vicario) in various territories subject to the Republic of Florence, Gonfaloniere of his Company, Prior, Gonfaloniere of Justice and Ambassador on a variety of missions. He died in 1475.

**Madonna of the Candlesticks**, polychrome terracotta relief, by Tommaso Fiamberti (Campione d'Italia, Como? active from 1498 to 1524).

**Nativity**, a marble roundel, by Antonio Rossellino. This splendid relief, with its delicate landscape, thronged with figures of dwindling sizes, in accordance with the rules of perspective laid down by Ghiberti, when he cast his famous "Paradise" Doors for the Florentine Baptistery, was probably carved around 1470.

**Madonna and Child with Angels**, a polychrome terracotta relief, by Antonio Rossellino.

**Little St. John the Baptist**, a marble bust, by Antonio Rossellino.

**Young Boy**, a marble bust, by Antonio Rossellino; both these busts standing on a great, heavily restored **Sacristy Side-board** or **Credenza**, Florentine, 15th century.

**Francesco Sassetti**, a marble portrait bust (1464), by Antonio Rossellino. This rich Florentine merchant, later (1485) asked Domenico Ghirlandaio to fresco his family chapel in Santa Trinita (Florence). He was both a friend and supporter of Lorenzo de' Medici, shown near him in the Chapel frescoes.

**Madonna and Child**, a partially coloured terracotta relief with a bracket-frame, Florentine, 15th century.

**Madonna and Child**, a natural terracotta relief, by Matteo Civitali's Circle.

**Little St. John the Baptist**, a marble statuette, by Antonio Rossellino.

**Francesco Sforza**, a marble profile in relief, by Giancristoforo Romano (Rome 1470 - Loreto 1512). Trained by Andrea Bregno, in Rome, the artist was both a sculptor and medallist of classical elegance. He later worked in Ferrara for Beatrice d'Este and in Milan, at the Sforza court, where he probably met the sitter of this portrait for the first time. Towards the end of his

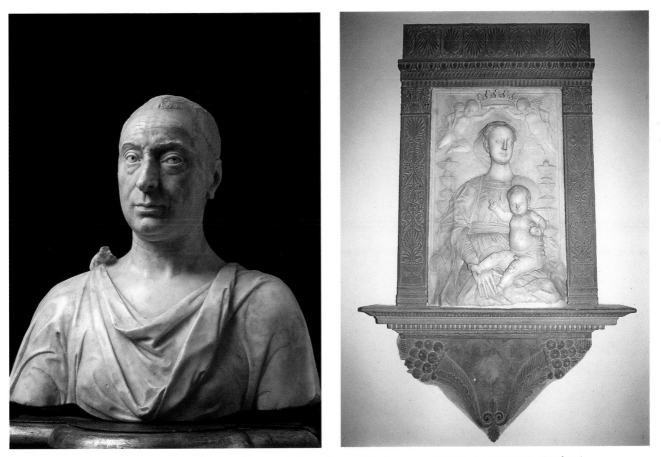

**Francesco Sassetti,** marble bust by *Antonio Rossellino* and **Madonna and Child,** by *Tommaso Fiamberti.*

life, he worked with Bramante on the Basilica of Loreto.

**Tabernacle for the Eucharist,** by Desiderio da Settignano (Settignano c. 1430 - Florence 1464). One of Donatello's numerous followers, Desiderio was registered as a member of the Florentine Stone-cutters and Wood-carvers Guild in 1453. Although he used Donatello's painterly "schiacciato" technique, he achieves a serene harmony, that differs noticeably from the much more dramatic and incisive creations of his master.

**Inlaid wooden chest,** Florentine, 16th century.

**Federico da Montefeltro,** marble panel with profile in relief, by Giancristoforo Romano. Federico da Montefeltro, duke of Urbino, was a loyal war-leader of rare valour and prudence. An ally of the Sforza family and of the Florentines, he and his consort, Battista Sforza (see Laurana's portrait of the latter in this room) were continually surrounded by a court of humanists. This profile reminds one of the duke's portrait by Piero della Francesca, at the Uffizi. The duke always had himself portrayed from the left, as his right eye had been gouged out in battle: so as to extend the range of vision of his remaining eye, he had had the bridge of his nose cut-away, as one can see in this portrait.

**Giuliano di Piero de' Medici,** a marble portrait bust, Florentine, 15th century.

**Madonna and Child,** by Tommaso Fiamberti, a marble relief, with a sand-stone bracket-frame.

**Pietro Mellini,** a marble portrait bust, by Benedetto da Maiano (1442-1497). As architect and sculptor, Benedetto was much influenced by Brunelleschi's sober harmony. The rich merchant Mellini (Benedetto's patron), portrayed here (1474) with ghirlandaioish detail and ironic bonhomie, also commissioned Benedetto's *Pulpit* in Santa Croce (1472-5). The beautiful *Door* of the Lilies Room in Palazzo della Signoria (1481) and the 1489 project for *Palazzo Strozzi* were also by Benedetto da Maiano.

**Tabernacle for the Eucharist,** by Mino da Fiesole (Poggi 1429-Florence 1484). "Of greater grace than well-versed in art" was Vasari's verdict, when describing this extremely active and technically gifted sculptor, who was a pupil of Antonio Rossellino and Desiderio da Settignano. Most of his early works were portrait busts (see the ones in this room). When he went to Rome, he worked with Bregno, increasing his knowledge of the ancient world. Returning to Florence, he resumed his activity as a portraitist and worked on a series of projects, such as the *Sepulchre* of Bernardo Giugni (1468) and the *Sepulchre of Count Hugo* in the Badia Fiorentina (1469-81).

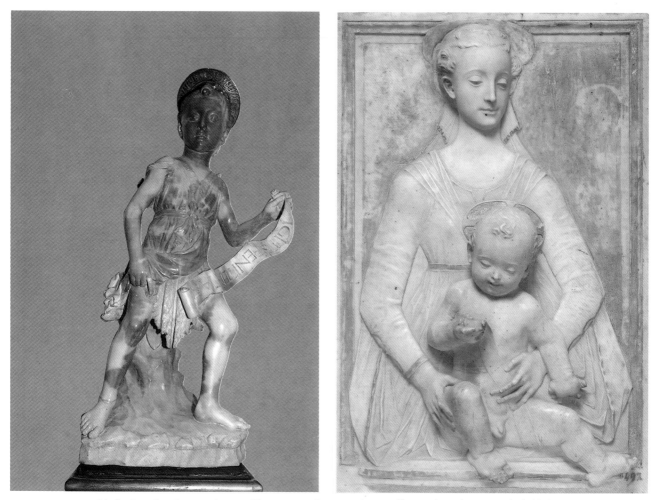

**Little St. John the Baptist**, marble statuette, by *Antonio Rossellino* and **Madonna and Child**, by *Mino da Fiesole*.

**Piero di Cosimo de' Medici**, a marble portrait bust, by Mino da Fiesole. Carved in 1453-56, it shows Piero the "Gouty" (born in 1416) in his late forties. Like his brother Giovanni, Piero had the humanist Carlo Marsuppini as one of his tutors. In 1450, he was Florentine Ambassador at the court of Francesco Sforza and in 1454, he was posted to Venice. He succeeded his father Cosimo, as head of the family business and had to confront a series of plots aimed at suppressing him and his family. When his banished opponents, banded together under the leadership of Bartolommeo Colleoni, marched on Florence, Piero was assisted by the king of Naples, the duke of Milan and by the duke of Montefeltro. He married Lucrezia Tornabuoni, who gave him five children: Lorenzo, Giuliano, Maria, Bianca and Nannina. He died in 1469 and was buried in San Lorenzo. A cultured art-lover and discriminating collector, he had the Chapel in Palazzo Medici frescoed by Gozzoli.

**Portrait of an Unknown Lady**, marble panel with profile in relief, Florentine, 15th century.

**Marcus Aurelius, Caesar Augustus**, marble panel with profile in relief, by Mino da Fiesole, indubitably carved after or during his Roman stay.

**Madonna and Child** (c. 1481), marble roundel carved in relief, with angel-head in the bracket, by Mino da Fiesole.

**Rinaldo della Luna**, a marble portrait bust (signed and dated 1461), by Mino da Fiesole. The youthful, bony face of the subject is an excellent example of Mino's early skill as a portraitist.

**Portrait of a Young Lady**, profile in relief on a marble panel, by Mino da Fiesole, believed to be a portrait of the artist's daughter, Caterina.

**Madonna and Child**, marble panel in relief, by Mino da Fiesole.

**Giovanni di Cosimo de'Medici**, a marble portrait bust, by Mino da Fiesole, carved around 1463 (?). Giovanni was born in 1421 and was tutored by Carlo Marsuppini. His chief interests were banking (he started his career as an apprentice when he was sixteen) and culture (the humanists Leon Battista Alberti, Giannozzo Manetti and Leonardo Dati, etc. were all friends of his). He was an enthusiastic collector of manuscript codexes. He married Maria Ginevra Albizi and had only one son, Cosimo. He died one year before his father, Cosimo the Elder, in 1463, apparently also afflicted by gout, the family illness.

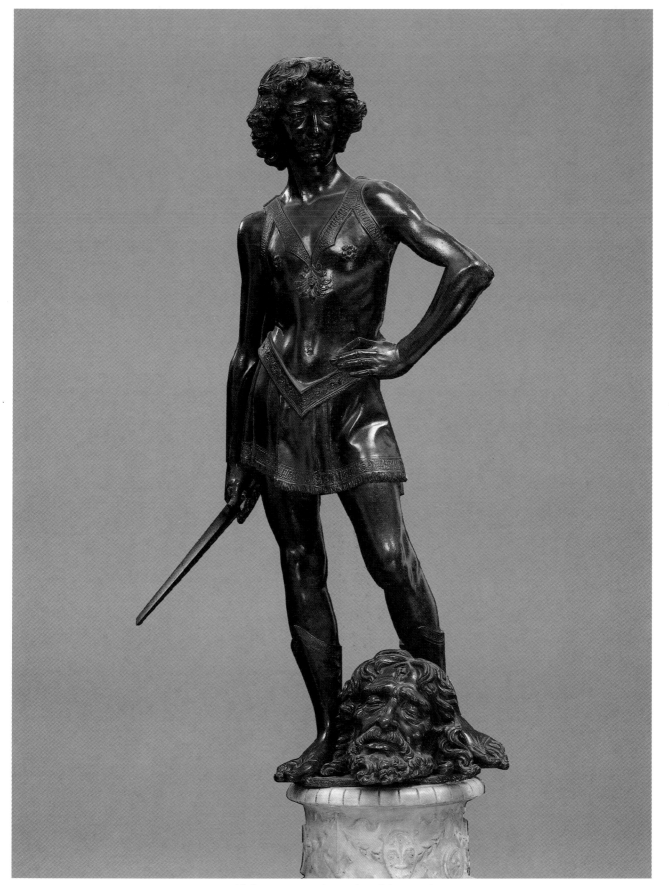

**David,** bronze statue, by *Andrea del Verrocchio.*

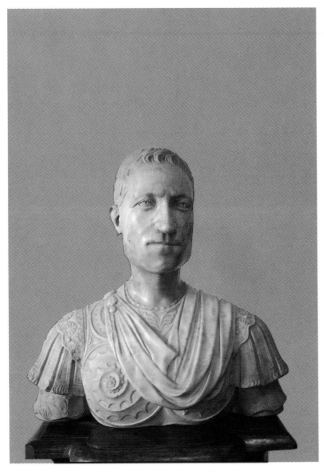

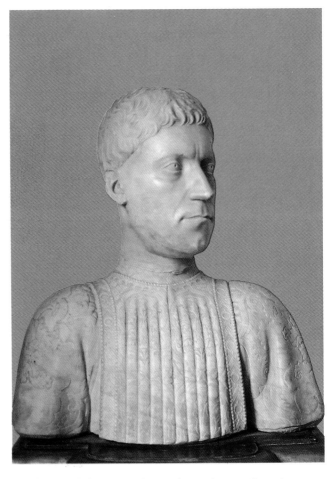

**Giovanni di Cosimo de' Medici** and **Piero di Cosimo de' Medici,** marble busts by Mino da Fiesole; left: side-view of *Andrea del Verrocchio's* **David.**

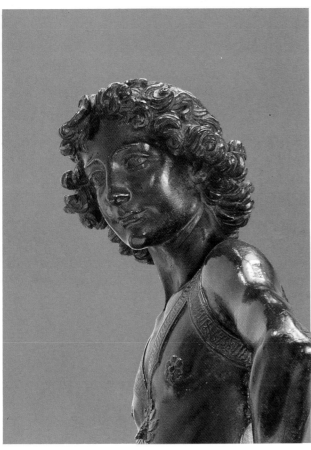

**David**, a bronze statue, by Andrea di Cione, known as Verrocchio. Cast for the Medici Villa of Careggi, this celebrated bronze was sold by Lorenzo and Giuliano de' Medici to the Florentine Signoria (Government) in 1476 for 150 wide florins, wherefore one can surmise that it was made sometime between 1469 (when Piero de' Medici died and Verrocchio started working on his *Sepulchre* in San Lorenzo) and 1476. The model for the tranquil, ironically triumphant face of the boy is believed to have been young Leonardo da Vinci, at that time an apprentice in Verrocchio's workshop: a fairly credible hypothesis, if one compares *David's* decided chin and regular, intelligent features with Leonardo's supposed self portrait, at a slightly older age, in the *Adoration of the Magi* in the Uffizi Gallery. A fairly curious aspect is the victorious adolescent's tunic bordered in Arabic lettering, which seems to be based on Arabic inscriptions, probably copied by Verrocchio from objects or fabrics of Middle-eastern origin and believed by him to be in Hebrew — but apparently praising Allah and Mahomet!!

Cosimo IInd's shield, by *Gasparo Mola*.

# THE ARMOURY

(E – Second Floor). The Bargello arms and armour collection is based on the Carrand and Ressman legacies and on what is left of the Medici and Della Robbia Armouries, once exhibited at the Uffizi and largely dispersed, in 1775, during an enth rearrangement of the Gallery's contents. On or against the walls: **Duke Alexander de' Medici's crest**; a panel painting of **Peace**, French, 15th century; **Justice**, a detached fresco, by Francesco Salviati; **Giovanni delle Bande Nere**, a marble portrait bust of Cosimo I's father, by Francesco da Sangallo and other minor works. Since the Middle Ages, war-leaders and soldiers, in their search after deadly arms and impenetrable armour, stimulated the development of the armourer's craft. The object of a good cap-a-pie armour was to protect the body without impeding its movements. *Spaulders* (for the shoulders), *genouillères* (for the knee-caps), *cuishes* (for the thighs) and *greaves* (for the shins), *gauntlets* (hands) *bevors* (throat-guards) *sallets*, *morions* (for the head), etc. were forged to measure, after the armourer had found out exactly what was desired from the point of view of the metals to be employed, the use to which the arms or armour were to be put, the style, etc. One might say that every town in Europe had its own distinctive arms and armour. In the 15th century, for instance, the Milanese armourers enjoyed great fame and weapons from their forges were deemed of insuperable quality. First came the so-called "white" arms: long and short blades of every description and for the most varied and deadly uses, bows, cross-bows, spears, halberds, axes, maces, etc. followed by the first fire-arms, which became ever more precise and destructive. The great number of exhibits include: a Della Rovere **Cap-a-pie armour** that belonged to **Francesco Maria I**, decorated with diamond-point engraving, with garlands and a *Madonna and Child* on the breast-plate; part of an **Armour** made for **Francesco Maria II**, duke of Urbino, with the Della Rovere crest on the breast-plate; a small 15th century **Cannon or Falcon**, assembled from a number of iron parts, mounted on a small carriage with solid wheels. Among the arms and armour from the 16th and 17th century Medici collection, see Cosimo I's back and breast-plates: a **Parade Suit** in the "**Roman**" style, by Filippo Negroli of Milan (c. 1543); a burnished and chiselled **Parade Armour** made for **Francesco I de' Medici**; an iron **Burgonet** and **Collar-**

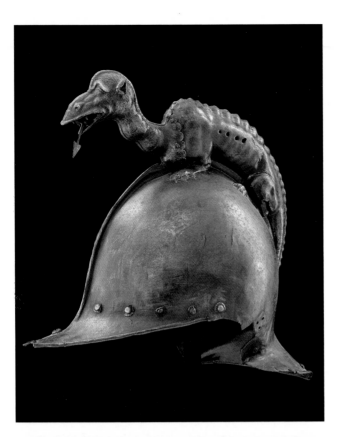

**guard**, damascened in copper and gold, made for Cosimo II (1608), by Gasparo Mola (c. 1580-1640). See the Medieval and later pieces from the Ressman and Carrand legacies dated between the 13th and 17th centuries, such as the hurling-arms, various types of swords and spears, as well as a fascinating array of fire-arms of Italian, Arabian or Turkish, Asiatic, Spanish, German, etc. provenance. The **Fowling-piece collection** from the Medici and Lorraine armouries of the 18th to 19th centuries is extremely interesting. Some of the curiosities include: a **Cap-a-pie Armour** made for Cosimo III, when he was a child; in the case below the Medici crest on the wall, an **Iron Collar** in three sections with iron points on its inner face (the **Collar of Justice**): the last instruments of the Tribunal of the Inquisition to survive the destruction of all the horrible apparatus in 1782. In other cases: the Magnificent Lorenzo de' Medici's **Hunting Horn**; a curiously toothed **Sword-breaking Dagger** of the 16th century and a **Nine-barrel Flint-lock Pistol**.

**Burgonet with Dragon Crest**, 16th century; below: 17th century **Model of Coat of Armour for Horse and Knight; Breast and Backplates of Parade Suit made for Cosimo Ist**, by *Filippo Negroli*, Milan, 16th century.

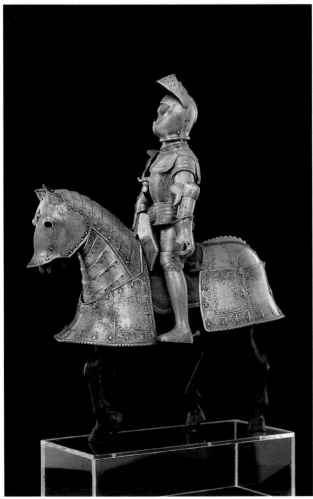

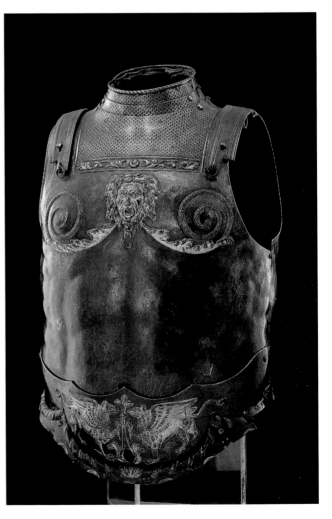

# THE MEDALS ROOMS

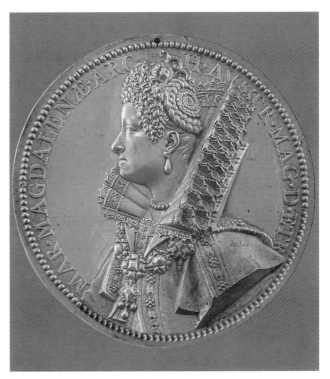

(F — Second Floor). Re-opened to the public on the 18th April 1990, the two rooms house a unique and splendid collection of 1032 numbered medals arranged chronologically in 13 cases, cast by European artists, from the 15th to the 19th century. See especially the medals by Antonio Pisano, known as Pisanello (1-17), where a humanistic taste for "Roman-style" profiles merges with the late-Gothic love of allegory, e.g.: the portraits of *Sigismondo Malatesta, John VIII Palaeologus, Francesco Maria Visconti, Niccolò Piccinino*, etc.; numbers 26-34 are by followers of Pisanello and of the School of Ferrara. Next come the medals by Matteo de' Pasti (35-52), the only medallist of his time capable of rivalling Pisanello, e.g.: *Self-portrait*, portraits of *Sigismondo Malatesta, Isotta degli Atti*, etc.; of further interest: the portrait of *Mahomet II* (87) by Costanzo di Ferrara and of *Elisabetta Gonzaga*, by Adriano Fiorentino. See also the portraits of *Cosimo de' Medici the Elder* (186-188) by Florentine artists and various medals by Bertoldo di Giovanni (believed to be the illegitimate son of Giovanni de' Medici) two of which commemorate the *Pazzi Plot* (193-194), as well as the portraits of *Lorenzo the Magnificent* (198-199), *Marsilio Ficino* (201) by Niccolò di Forzore Spinelli and two portraits of *Savonarola* (217-218); the profiles of *Alessandro de' Medici* (231) and of *Giovanni delle Bande Nere* (230), by Francesco da Sangallo. Also of interest: the portraits of *Cosimo I de' Medici* (241-246), by Domenico de' Vetri and the portrait of *François I of France* (250), by Benvenuto Cellini; the potraits of *Francesco de' Medici* (347), by Guillaume Dupré, of *Henri II of France* (563), by Pompeo Leoni and of the Sultan of the Ottoman Empire, *Suleiman the Magnificent* (677). Further on one comes to the portraits of *Cosimo III de' Medici* (699), by Massimiliano Soldani and of *Cosimo II* (758), by Antonio Selvi. The last case contains an "international" selection of portraits, which includes the bony, ironic profile of *Erasmus of Rotterdam*, cast by Quentyn Metsys (1017).

On the walls, from right to left:

**Two Shepherds**, rectangular marble relief, attributed to Orazio Marinali (Bassano 1643-Vicenza 1720).

**Hercules slaying the Hydra** and **Hercules and the Nemean Lion**, two bronze roundels in relief, highlighted in gold, by Pier Jacopo Alari Bonacolsi, known as the Ancient (Mantua c. 1455-Mantua 1528) [Case A].

**Mould** in stone, with the symbols of the Merchant Corporations, Florentine, 15th century.

**Mould** in stone, with letters of the alphabet and Florentine crests, Florentine, 15th century.

**Virginia Pucci Ridolfi**, marble bust, by Domenico Poggini (Florence 1520-90).

**Ganimede offering a cup to Jupiter in the guise of an eagle**, bi-coloured marble panel, 1st century Roman art, with 17th century additions.

**Venetian Gentleman**, bust in white marble (the head),

Medal with effigy of **Maria Maddalena of Austria,** by *Guillaume Dupré*; below: **Virginia Pucci Ridolfi,** portrait bust by *Domenico Poggini*.

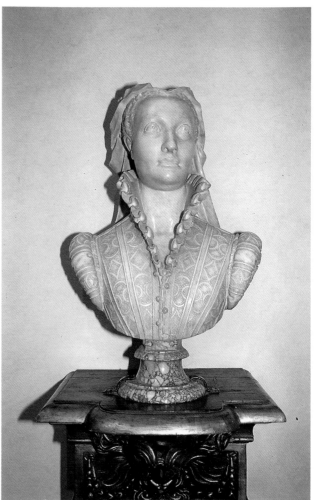

Partial view of the Medals Rooms; below: bust of the **Cardinal Paolo Emilio Zacchia Rondanini**, by *Alessandro Algardi*.

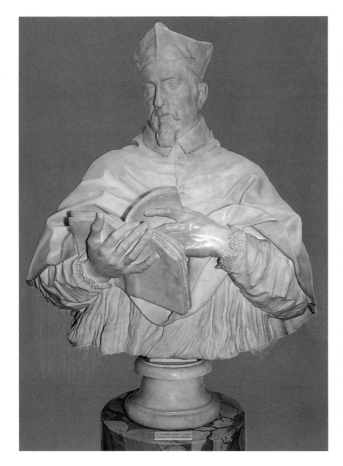

the robe in grey marble, by sculptor of Alessandro Vittoria's Circle.

**Resurrection** (Medici Travelling Altar), a bronze panel in relief with frame and arch surmounted by *Cherubs* bearing garlands and the Medici crest; the *Almighty* surrounded by *Angels* beneath the arch, by sculptor of Jacopo Sansovino's Circle.

**Two Triumphal Processions**, a pair of stone panels in relief (the themes probably based on Petrarch's *Trionfi*), Florentine, 15th century.

**Head of Christ**, oval bronze panel, 16th century.

**Medals from the Carrand Collection**, such as the profiles of **Maria de' Medici**, queen of France and **Maria Maddalena of Austria**, by Guillaume Dupré (1575-1640). [Case B].

**Triumph**, a stone panel in relief, similar to the preceding pair, but narrower, Florentine, 15th century.

**Costanza Bonarelli**, marble bust, by Gian Lorenzo Bernini (Naples 1598-Rome 1680).

**Model** in terracotta of a public fountain, by Bernini.

**The Death of St. Francis Xavier**, gilded bronze panel, by Massimiliano Benzi Soldani.

**Cardinal Paolo Emilio Zacchia Rondanini**, marble bust, by Alessandro Algardi (1595-1654).

**Ecstasy of St. Theresa**, gilded bronze panel, companion piece to the above, by Massimiliano Benzi Soldani.

**St. Joseph's Transit**, gilded bronze panel, companion piece to both the above, by Massimiliano Benzi Soldani.

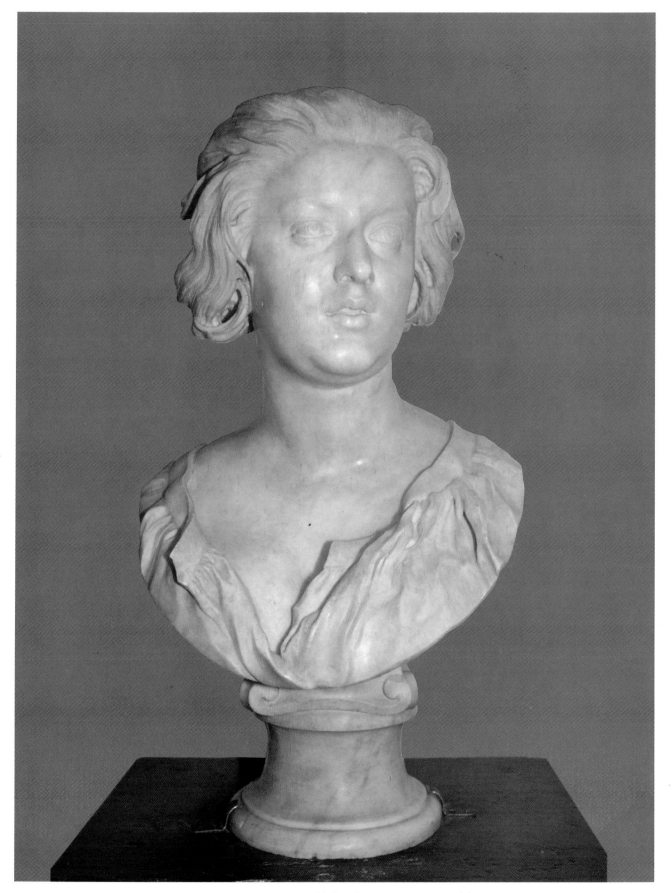

**Costanza Bonarelli,** marble bust by *Gian Lorenzo Bernini*.

## ESSENTIAL BIBLIOGRAPHY

*Guida di Firenze* – Augusto Garneri, Firenze, 1890.
*Dictionary of Classical Antiquities* – Oskar Seyffert, Henry Nettle-ship, J.E. Sandys, London, Swan Sonnenschein and Co. Ltd., 1894.
*Firenze* – F. Lumachi, Società Editrice Fiorentina, Firenze, 1937.
*Leonardo da Vinci – The Artist* – Ludwig Goldschmieder, Phaidon Press, Oxford, 1945.
*Italian Maiolica* – Bernard Rackham, Faber & Faber, London, 1952.
*The Greek Myths* – Robert Graves, Penguin Books, Harmondsworth, Middlesex, Great Britain, 1962.
*Verrocchio* – Alberto Busignani, Sadea/Sansoni, Firenze, 1966.
*Scultura Italiana, Il Gotico* – Enzo Carli, Electa, Milano, 1967.
*Capolavori del Museo degli Argenti* – Kirsten Aschengreen Piacenti, Ed. Arnaud, Firenze, 1969.
*Donatello* – G. Gaeta Bertelà, Becocci Ed., Firenze, 1970.
*Storia di Firenze* – Robert Davidsohn, G.C. Sansoni, Firenze, 1972.
*Firenze e Dintorni* – Touring Club Italiano, Milano 1974.
*The Oxford Companion to Art* – H. Osborne, Oxford, Clarendon Press, 1975.
*The Connoisseur Complete Encyclopedia of Antiques*, Rainbird Reference Books, London 1975.
*Casa Buonarroti* – Charles de Tolnay, Ed. Arnaud, Firenze, 1976.
*Vite* – di Giorgio Vasari, U.T.E.T., Torino, 1978.
*Oeuvres complètes* – M. de Montaigne, Gallimard, Dijon, 1980.
*Opere* – di Benvenuto Cellini, U.T.E.T., Torino, 1980.
*L'Opera del Cellini* – Charles Avery e Susanne Barbaglia, Rizzoli Ed., Milano, 1981.
*Profili Medicei* – E. Grassellini e A. Fracassini, SP44, Firenze, 1982.
*Museo Nazionale del Bargello* – P. Barocchi e G. Gaeta Bertelà, S.P.E.S., Firenze, 1984.
*Donatello e i Suoi* – Scultura Fiorentina del Primo Rinascimento – Phipps Darr e Giorgio Bonsanti, Founders Society, Detroit Institute of Arts, La Casa Usher e Arnoldo Mondadori, Firenze, 1986.
*Capolavori e Restauri* – Cantini Edizioni d'Arte S.p.A., Firenze, 1986/87.